COVER. Totem poles in the Great Hall, Museum of Anthropology
END PAPERS. Bear and human on a totem pole from the deserted Haida village of
Tanoo (catalogue no. A50000d)

Reprinted 1983, 1990, 1991, 1993

ISBN 0-7748-0141-7

Canadian Cataloguing in Publication Data

Halpin Marjorie M., 1937—
 Totem poles, an illustrated guide

(Museum notes/UBC Museum of Anthropology ; 3)
Bibliography: p.
ISBN 0-7748-0141-7 (pbk.)

 1. Totem poles — British Columbia — Vancouver. 2. Indians of North America —
Northwest coast of North America — Art. I. Title. II. Series: Museum notes (University
of British Columbia. Museum of Anthropology); 3.
E98.T65H34 736'.4 C78-002100-2

Museum Note Design: W. McLennan Printed in Canada

Totem Poles
An Illustrated Guide

Marjorie M. Halpin

Foreword by Michael M. Ames

Museum Note No. 3

University of British Columbia Press
in association with
the U.B.C. Museum of Anthropology

UBCPress / Vancouver

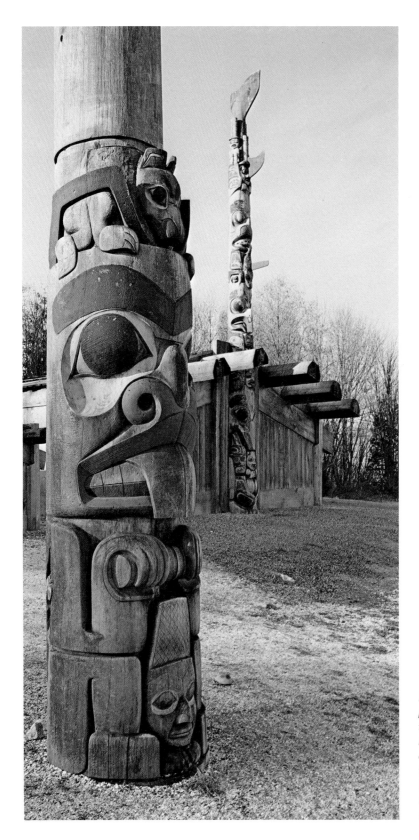

Figure 1. Modern Haida totem poles and houses on the grounds of the Museum of Anthropology recreate the cultural achievements of the past in a natural setting. In the foreground is a magnificent Haida beaver, one of the masterpieces of the museum's collection.

Contents

Figure 2. Haida totem poles in the Great Hall at night.

Foreword

This guide is designed to help people see and appreciate totem poles and other massive wood carvings which are unique to the Indian peoples of the Pacific Northwest Coast. Examples of these great works of sculpture, illustrated in this book, may be found in and around the University of B.C. Museum of Anthropology.

Dr. Marjorie Halpin, who is a curator of ethnology in the Museum of Anthropology and a specialist on Northwest Coast Indian cultures, describes in the following pages the different ways one might "read" or interpret totem poles. They can be viewed as fine specimens of a highly developed and artistic tradition. They can also be seen as artifacts or records of the complex cultures that once flourished along the North Pacific Coast for hundreds of years and which continue in modified form to this day. In this perspective social and economic factors as well as aesthetic achievement become relevant. And the history of the production and use of massive carvings on the coast can be used to trace the history of the fortunes and misfortunes that beset the Indian peoples themselves.

These magnificent wood carvings are imaginative creations that stimulate our own imaginations as well. We might allow, if even for a moment or two, our thoughts and feelings to wander freely among the marvelous beasts and monsters that surround us as we stand in the Great Hall of the Museum. The carvings are to be enjoyed, thought about, and even incorporated into our dreaming. Like all great human achievements, they are grand opportunities to exercise our minds and to stretch our imaginations.

While carvings illustrated in this book are from the fine collection of the Museum of Anthropology, the methods of interpretation described by Dr. Halpin can be applied to totem poles wherever they may be found. It is hoped that this guide will also make it easier to distinguish between Indian carvings and the plastic kitsch and other crude imitations now widely produced and used by non-Indians as their own souvenirs and crests.

The Museum would like to thank Drs. Harry B. Hawthorn and David Macaree, Professor Audrey Hawthorn, and Mr. Peter Macnair for their guidance in the preparation of this book. We are also pleased to acknowledge the Leon and Thea Koerner Foundation and the Museum of Anthropology Shop volunteers for grants that have made publication of the Museum Note series possible.

Michael M. Ames
Director, Museum of Anthropology

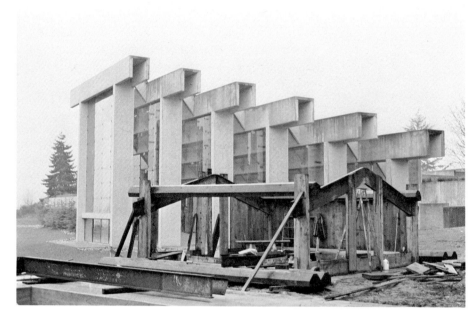

Figure 3. A reconstructed Haida house demonstrates the traditional post-and-beam architecture which inspired the museum design.

Figure 4. View of the Great Hall showing post-and-beam construction. The ceiling rises to 41 metres to accommodate the totem poles inside.

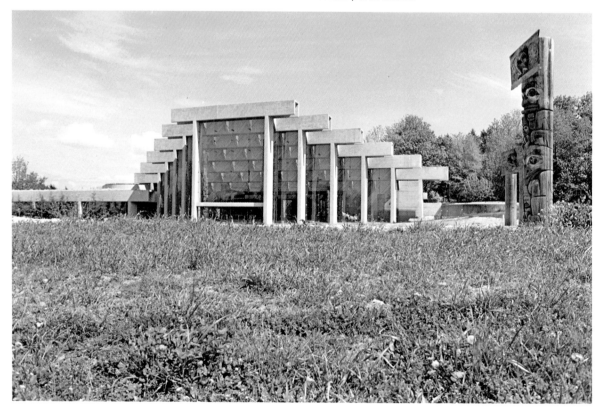

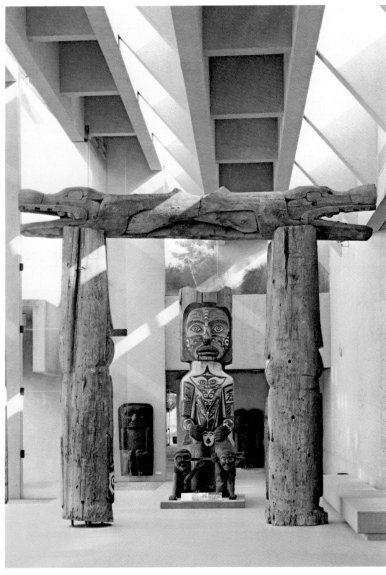

Figure 5. Southern Kwagiutl house posts and beam in the Great Hall (see also Figures 28, 29, 30).

Introduction

This short guide provides background information about and suggests ways of looking at totem poles and other large works of sculpture by the Indian peoples of coastal British Columbia. However, it should be emphasized that there is no easy formula for penetrating instantly the aesthetic and symbolic secrets of this powerful art. Even the specialists who study it — anthropologists and art historians — are just beginning to understand its complicated rules of design and composition. More problematical still are the ideas or symbolic meanings of the forms and their interrelationships with other aspects of Indian culture — religion, mythology, social organization — which constituted the context within which this sculpture was created and used.

It has been said that in art familiarity breeds affection. To let the eyes follow and learn these forms, to compare one with another, and to return again and again to those found most pleasing or puzzling is to begin to turn that initial strangeness of unfamiliar form into the familiarity which will lead to greater pleasure in aesthetic contemplation.

No amount of visual contemplation will lead to an understanding of the cultural context and meaning of totem poles. This requires intensive study of the detailed accounts written about them, although a short introduction will be included later in this publication. Because of an increasing awareness of the complexity of native thought and the multi-level nature of its expression in those kinds of objects to which the label "art" is given, it is becoming obvious that to attempt simply to "explain" these objects is to reduce complicated masterpieces to simple stereotypes which could be easily misunderstood. It is hoped that this guide will contribute to an appreciation for the form and meaning of totem poles. Totem poles should be treated as beautiful objects of contemplation as well as artifacts that inform or educate us about the past. They are complex forms that can and should be "read" on a number of levels: social, economic, mythological, religious, and aesthetic. These massive carvings represent a cultural tradition that flourished along our coastline for centuries, which was briefly and brilliantly over-extended, almost completely devastated as a result of contact with the Europeans, and which is today enjoying an enthusiastic revival.

Figure 6. Totem pole salvage at the deserted Haida village of Ninstints by the joint University of British Columbia and B.C. Provincial Museum expedition in 1957. The totem pole being lowered is now in the Museum of Anthropology (catalogue no. A50017).

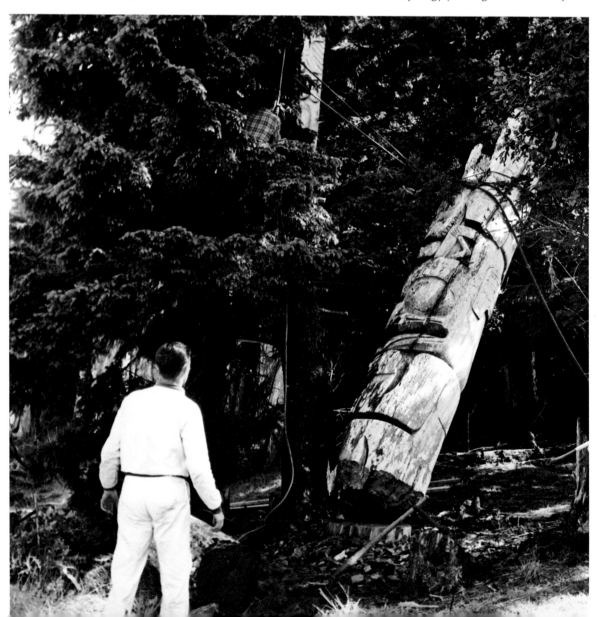

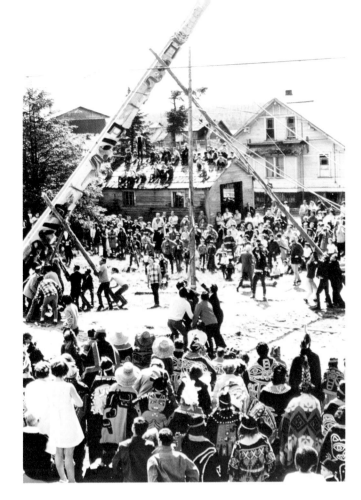

Figure 7. Raising a modern totem pole by Haida artist Robert Davidson in the village of Masset in 1969.

Figure 8. Raising a modern totem pole by the Gitksan (Tsimshian) artists of 'Ksan at the Museum of Anthropology in 1980.

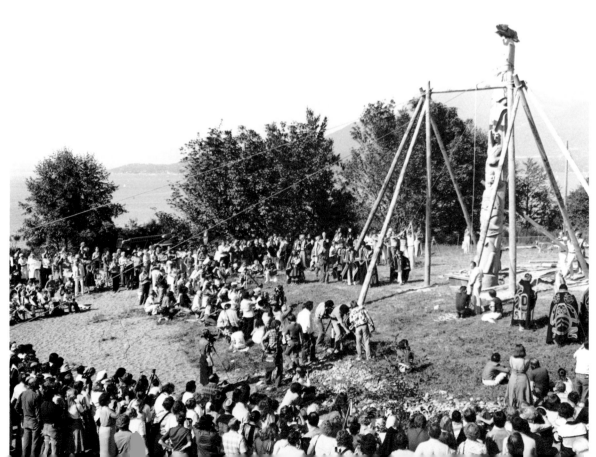

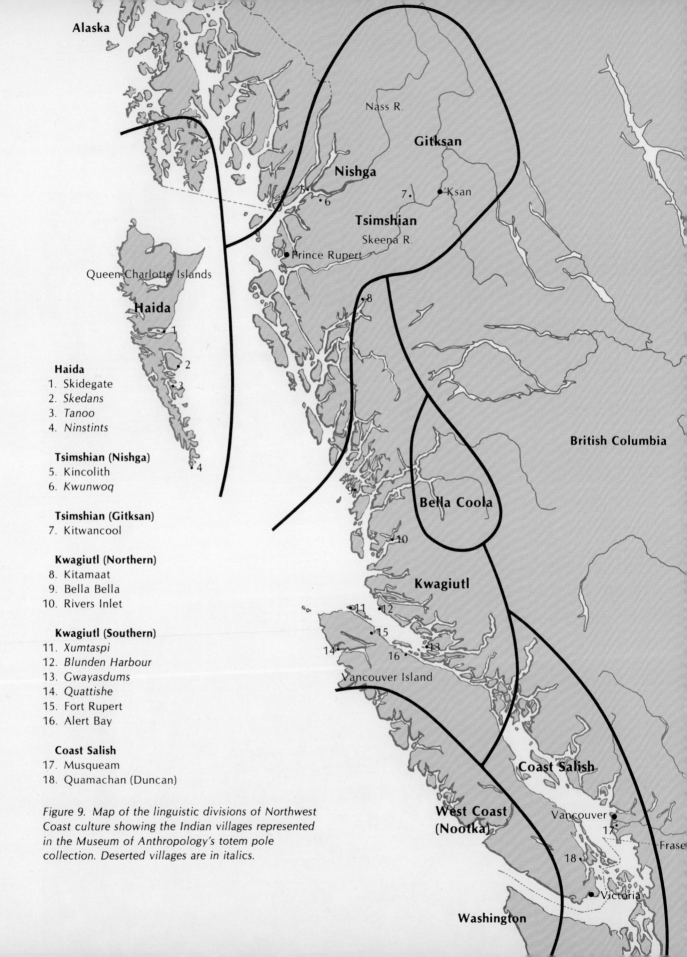

Alaska

Nass R.

Gitksan

Nishga

5•
•6

Tsimshian

7• •'Ksan

Skeena R.

•Prince Rupert

Queen Charlotte Islands

Haida

•1

•8

British Columbia

•2

•3

Haida
1. Skidegate
2. *Skedans*
3. *Tanoo*
4. *Ninstints*

•4

Tsimshian (Nishga)
5. Kincolith
6. *Kwunwoq*

Tsimshian (Gitksan)
7. Kitwancool

•9

Bella Coola

Kwagiutl (Northern)
8. Kitamaat
9. Bella Bella
10. Rivers Inlet

•10

Kwagiutl

Kwagiutl (Southern)
11. *Xumtaspi*
12. *Blunden Harbour*
13. *Gwayasdums*
14. *Quattishe*
15. Fort Rupert
16. Alert Bay

•11 •12

•15

14• •13

16•

Vancouver Island

Coast Salish
17. Musqueam
18. Quamachan (Duncan)

Coast Salish

Figure 9. Map of the linguistic divisions of Northwest Coast culture showing the Indian villages represented in the Museum of Anthropology's totem pole collection. Deserted villages are in italics.

West Coast (Nootka)

Vancouver •

•17

Fraser

18 •

• Victoria

Washington

Indian Cultures of the Northwest Coast

The Indians of coastal British Columbia developed some of the most complicated and distinctive cultures (ways of living in and thinking about the world) in native North America. Although these cultures exhibit considerable diversity, they have enough patterns in common to be classified together as comprising the Northwest Coast culture area. While the culture area extends north into Alaska and south into the states of Washington and Oregon, the totem poles and other large works of sculpture discussed in this book come exclusively from British Columbia, and the cultural groups discussed here will be restricted to those of this province.

Within the Northwest Coast culture area, anthropologists have classified local groups into large units speaking related languages, six of which are found within British Columbia: Haida, Tsimshian, Kwagiutl, Bella Coola, Nootka, and Coast Salish (see the map on the facing page).

Linguistic classification, however, seldom has much experiential reality to the people who have been so classified. As long as these names are recognized merely as useful labels for describing large groups of people who have their own names for their own communities, they are useful. Additionally, they have been perpetuated over several decades in both popular and scholarly writing and will serve as a guide to additional information about Indian cultures in books.

A great many books have been written about the Indians of the Northwest Coast. The anthropologist Franz Boas alone wrote more than 175 books and articles about the Kwagiutl peoples

Figure 10. The Southern Kwagiutl village of Gwayasdums on Gilford Island in 1900. Notice that the entrance to the house is through the mouth of the creature painted on the front.

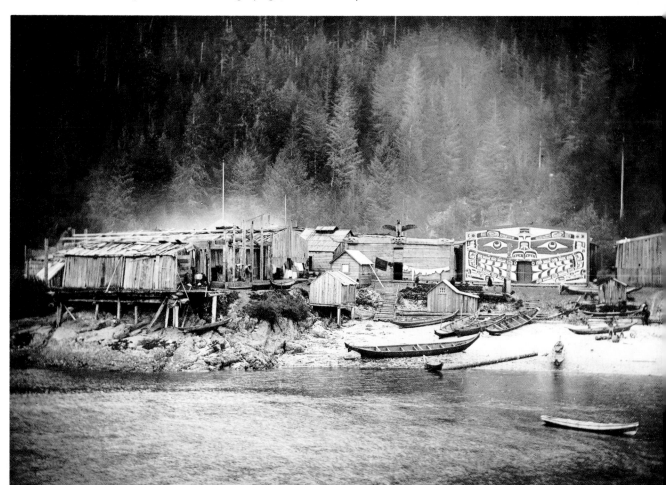

over a period of more than 50 years during which he attempted to describe and understand their society and culture. Why did he do so? He once wrote of anthropology as a liberating study: "The only means that will set us free is to sink into a new life, into an understanding of a thought, of a feeling, of a form of behavior that has not grown from the soil of our civilization, but rather has had its sources in another cultural tradition" (translated by and quoted in Goldman 1975:9). While few individuals have studied another culture as intensively as Boas did that of the Kwagiutl, the rest of us can read his writings and those of anthropologists, explorers, missionaries, linguists, travelers, pioneer residents, and others who have encountered and lived among people very different from ourselves. We can also appreciate their art and the other things they make as windows through which to look into other worlds. We will have difficulty in understanding what we see there, for, although all men share the experience of being human, the ways in which they express their humanity are various and differ widely.

There are numerous differences in the ways of life of Northwest Coast peoples, many of which anthropologists are still in the process of understanding. But for the purposes of this short background exposition, they can be treated as variations on five basic patterns. These are the patterns which intersected to create the cultural context out of which totem poles emerged: *wealth, family, mythology, ceremony,* and, of course, *carving.*

Figure 11. This dense forest on the west coast of Vancouver Island is characteristic of the Northwest Coast.

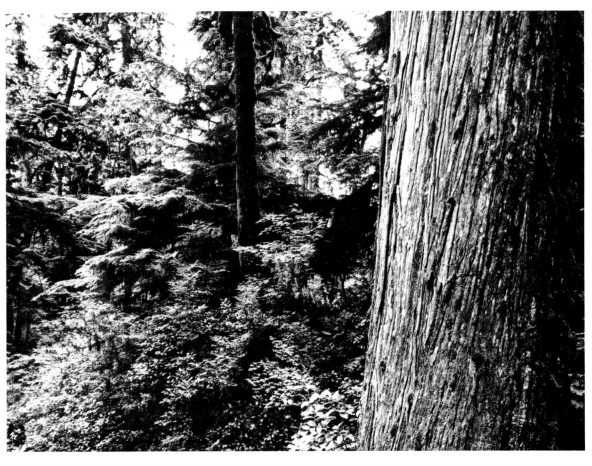

Wealth. In a narrow sense, wealth came from industrious exploitation by the people living here of the bountiful nature of the North Pacific coast, particularly its waters. The principal resource and dietary mainstay of the people was salmon, but other species of fish and sea mammals, even whales, were taken by a wide variety of devices: hooks, nets, weirs, harpoons, arrows, and others. Land animals were hunted to a lesser extent, principally by peoples living up the rivers from the coast itself. Women gathered shellfish, other beach and intertidal animals, and wild vegetable foods. The efficiency of Northwest Coast hunting and fishing technology, methods of preserving foods, and the sheer abundance of animal life available permitted the accumulation during the summer months of great surpluses of food and skins. This, in turn, permitted people living in different resource areas to exchange through gift and trade and to support the skillful members of their group who turned natural wealth into manufactured wealth objects such as blankets, canoes, boxes, and feast dishes and spoons. But wealth was not restricted to tangible things. Also considered as wealth were songs, dances, myths, names, crests (the figures represented on totem poles), and other privileges which had been acquired by the ancestors when the world was young and which were counted among the treasures of their descendants. The relationship between tangible and intangible forms of wealth was, in essence, that the former was a necessary condition for the glorification and ceremonial display of the latter. For example, to assume a great ancestral name meant that its new holder had to maintain and even elaborate its significance through the display and giving away of food and wealth objects.

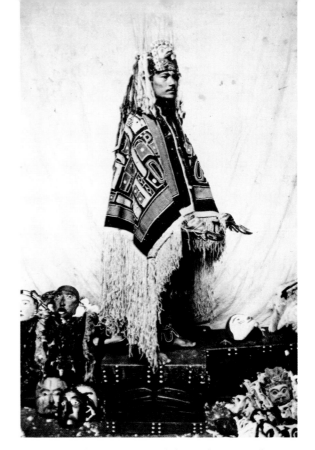

Figure 12. Chief Stiaowax of the Nishga (Tsimshian) in chief's regalia circa 1900. Notice that the proper way to hold the famous Raven rattle is what we would consider to be upside down.

Figure 13. A silver bracelet (catalogue no. A8093) by the renowned Haida artist Charles Edenshaw (1839-1920). Native artists began to make jewelry from heated and hammered silver coins in the 19th century.

7

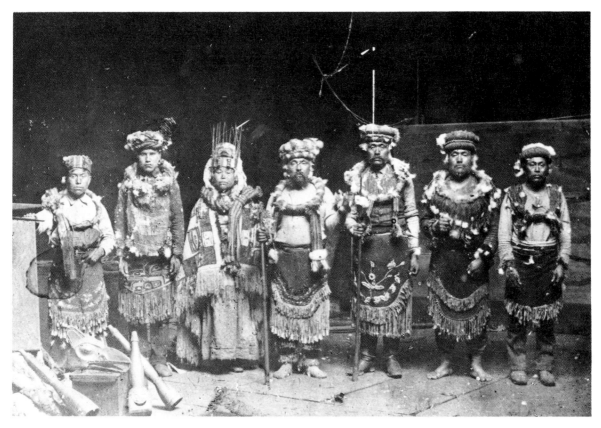

Family. Traditional societies such as those of the Northwest Coast were basically organized according to kinship, with ties of descent and marriage rather than those of occupation or politics being the primary bonds that held people together. While rules of descent and inheritance varied along the coast, the genealogies by which peoples were connected to their ancestors were remembered and recounted over generations. Whether relationships were reckoned matrilineally (through the mother's line only), patrilineally (through the father's line), or bilaterally (through both lines, as in Western culture), they were the all-important transmission lines along which ancestral privileges and knowledge descended to the present and upon which the continuity of the family group depended. Relationships of marriage, on the other hand, were the ties binding different family groups together into larger and more powerful alliances. Marriage bonds were made stronger by gifts and sometimes through the transfer of privileges, and the

Figure 14. A Nishga (Tsimshian) family from Gitlakdamixs Village wearing dance aprons and head and neck rings of sacred red cedar bark for the winter dances. White eagle down, a symbol of peace, can be seen clinging to them.

same groups tended to continue to intermarry over the years so as to strengthen their alliance. Marriages often turned former enemies into allies and were carefully arranged according to rules as to whom one could and could not marry. Closely related people lived together in great plank houses and constituted what have been called the corporate groups of the societies — those which owned wealth and territories in common. All corporate family groups were controlled by headmen who in some areas might become chiefs of several families, whole villages, or groups of villages banded together into confederacy-like associations. The chiefs were ceremonial leaders as well as the political-economic managers of their groups, receiving and redistributing food and other goods.

Mythology. There were two kinds of myths on the Northwest Coast — those which were known to and could be told by everyone and those which were the private property of particular families and could only be told by their members. Both kinds tell of a primordial age before the world became as it is now, a time when finite divisions between humans, animals, and spirits had not yet been created and beings could transform themselves from one form into another — humans could become animals by putting on skins, animals could become humans by taking them off, humans could marry animals and spirit beings. All realms of existence (water, earth, sky, and the land of the dead) were interconnected by beings who could pass among them. It was a time when everything was possible, when all boundaries were fluid and forms were plastic; a time when the fundamental opposites of life — natural/supernatural, man/woman, life/death, human/animal, hunter/hunted, eater/eaten — were interchangeable aspects of each other. It was a time when cosmic power accelerated the natural processes of change into miracles of transformation. It was a time now lost but remembered. It was a world now gone, but one that people recreated in art and ritual. Through ceremonial and artistic re-enactment of their heritage, through dance, song, and ritual acting, people maintained continuity with their genesis. So, even though mythological time belonged to long ago, before mankind became separated and distinguished from animals and nature, the memory of it could be kept alive.

Figure 15. Time-lapse photograph of a Southern Kwagiutl transformation mask from Kingcome Inlet showing an eagle opening to reveal a human (catalogue no. A4497).

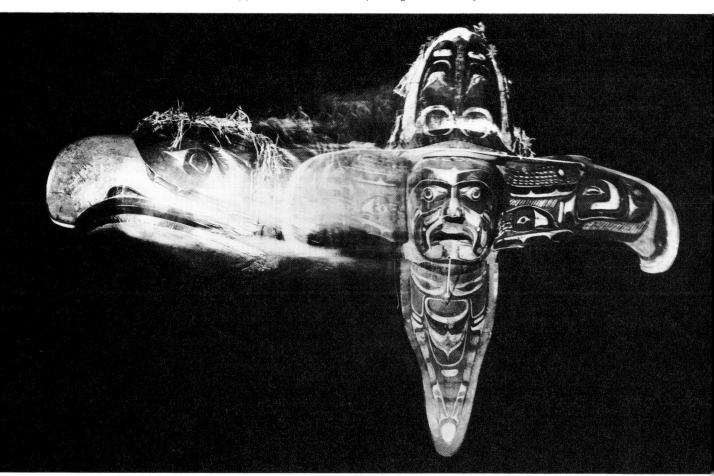

9

The myths which everyone could tell concerned mainly the change of that other world into this one, as primordial time became the irreversible time that takes us all toward death. Like Kipling's *Just-So Stories*, they explained how animals became as they are, how humans learned to fish the salmon, and how fire originated. They recounted the exploits and misadventures of Raven and Mink, the greedy tricksters, and of hosts of other creatures who are now unseen, except for occasional glimpses in the dark forests. The family myths, on the other hand, told of family origins, of ancestors who came down from the sky as birds or who married mythical animals and shining celestial beings; they told of the wanderings of the ancestors, their settlement in their present locations, and their acquisition of fishing spots, hunting territories, and berry grounds. Above all, they told of the acquisition of the privileges and powers which defined the greatness of the family line. Paramount among these were those rights whose representations the family could display on totem poles and ceremonial objects to broadcast their heritage to others.

Ceremony. While summer was a time of intensive economic activity, winter on the Northwest Coast was the time of feasting and ceremony during which families asserted their greatness and recreated the spirit encounters and experiences of their ancestors. Feasting took place in the context of special ritual occasions commemorating important events in the life of the people, such as birth, death, a new house, a new heir, the giving of a Winter Dance, or the display of supernatural properties and powers. A characteristic feature of these winter ritual occasions was the distribution of wealth to invited guests, a practice anthropologists refer to as *potlatching*.

There have been many explanations for the ritual occasion that involved potlatch giftgiving — that it converted wealth into prestige through the principles of conspicuous demonstration (the giver deriving social prestige through the size of his gifts); that it served as an economic investment through the redistribution of resources between groups owning territories of different and variable productivity; that it maintained society by reinforcing social bonds between family groups; and that, through the rivalry of aggressive giftgiving, "fighting with property" was substituted for "fighting with weapons". The scholarly debate has gone on for decades and likely will continue (e.g., Barnett 1938, Codere 1950, Goldman 1975). For our purposes here, three aspects of the winter ceremonies are especially important:

1) that they were the context within which totem poles were raised;

2) that the guests to whom wealth was given constituted witnesses whose presence publicly legitimized the crests on the totem pole and the other privileges which were being claimed by the host family; and

3) that the feasts, ceremonies, and potlatches were occasions for the carving and use of many other artifacts characteristic of Northwest Coast cultures (large feast dishes, utensils, masks, rattles, etc.).

Figure 16. A Coast Salish potlatch at an old Songhees village in Victoria Harbour, circa 1870. While guests assemble below, the host family prepares to distribute gifts from the roof.

Figure 17. Southern Kwagiutl dancers pose in the costumes of the winter dance in 1914.

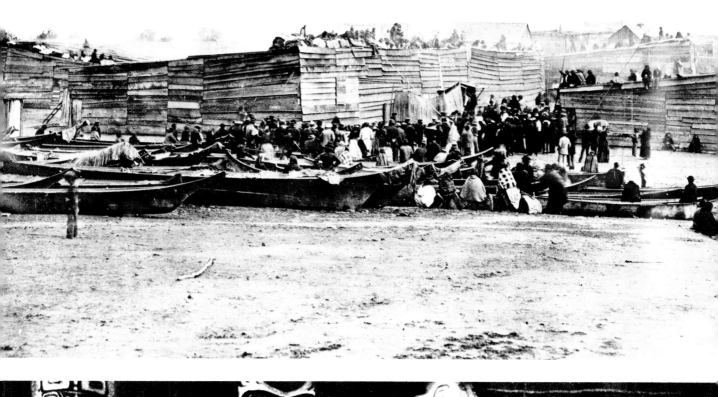

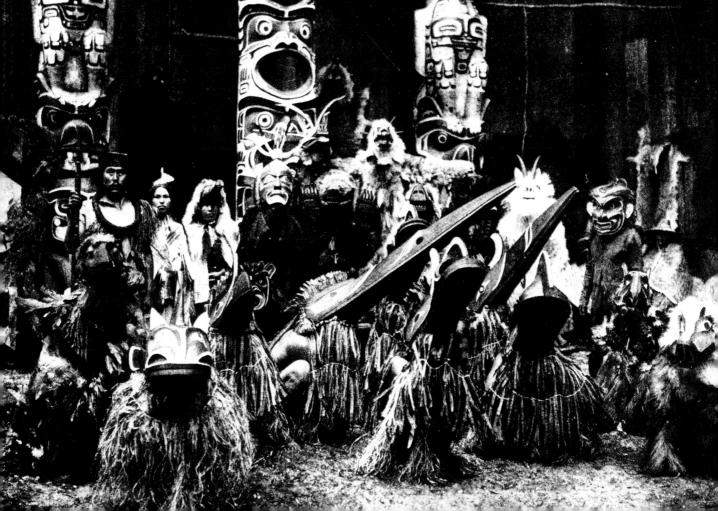

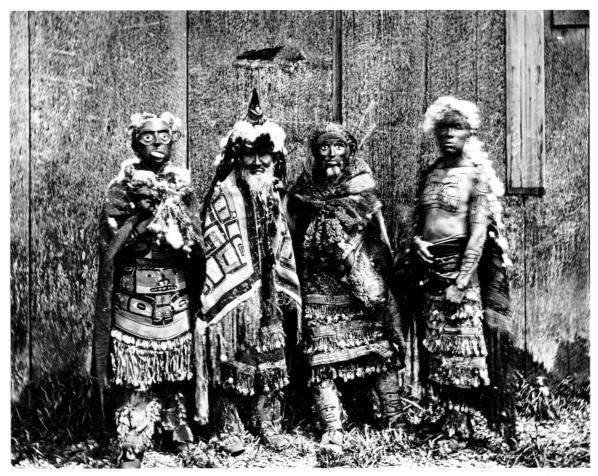

Figure 18. *Haida chiefs of Masset in eagle down and winter dance regalia in 1881. Note the tattoo on the man's chest at right.*

Figure 19. *Southern Kwagiutl canoe-shaped feast dish (catalogue no. A1798).*

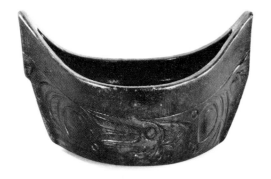

Dances, during which people symbolically recreated the original encounters of their ancestors with spirit beings from other realms, were an important part of the winter ceremonials. These were profoundly religious events at which masks were worn and dancers were transformed into the spirits and spirit animals from which their ancestors had received power and other gifts. While totem poles are essentially commemorative of ancestry and its continuation to the present time, Winter Dances ritually turned time back to the ancestral period of transformation. Thus, while some of the animals and other beings represented on totem poles and by masks were the same, their ritual context and uses were quite different: the pole established the past in the present and the masked performance returned someone in the present to his or her primordial past.

Carving. Woodcarving on the Northwest Coast was unsurpassed elsewhere in native North America, and perhaps in the world. The wide range and excellence of the wooden objects which comprised the principal material expressions of these cultures can be readily seen and quickly appreciated. From the dense coastal forests, carvers took trees and transformed them into most of the domestic and ceremonial objects used by the people, including houses, canoes, boxes, dishes, ladles, fishhooks, screens, masks, whistles, rattles, headdresses, and, of course, totem poles. Totem poles were carved of red cedar — soft, straight-grained, and long-lasting.

The traditional woodworking tool kit included chisels, adzes, and knives with blades of stone, bone, antler, and shell, bone-pointed drills, stone hammers, and wooden wedges. The earliest European explorers also reported the presence of iron and copper used in native tools and as personal adornments. Since the Indians had not developed techniques for processing metals, it is generally assumed that the iron came from wrecked Asian vessels carried to the North Pacific Coast by ocean currents. Copper was probably found in local outcrops and hammered into shape. With the arrival of the white man, however, the natives' use of trade metal in carving tools rapidly increased, as did their carving production. Many wooden objects were also painted, traditionally with earth pigments ground and then mixed with some binding agent, such as salmon eggs. The colours used were primarily black and red, although blue and blue-green and, occasionally, white and yellow were also found. Brushes were commonly made of porcupine hair. The original native paints and brushes were eventually replaced by those acquired from traders.

Figure 20. Fibre for basketry, clothing, rope, and regalia was made from the shredded inner bark of the cedar tree. The outer bark was used for kindling.

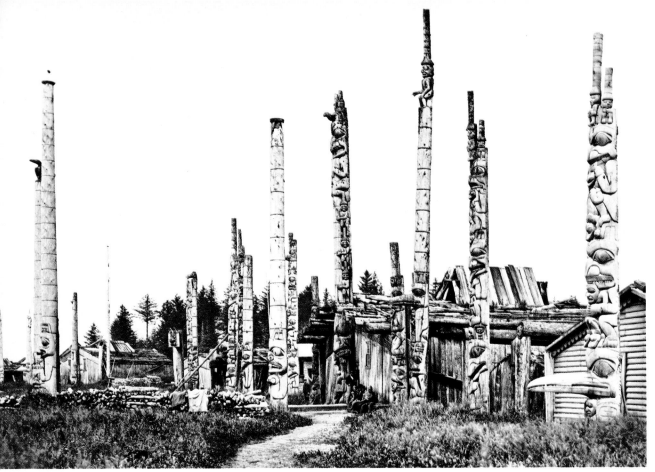

Figure 21. The Haida village of Masset in 1881.

Figure 22. A Haida totem pole at the deserted village of Skedans before its removal by the joint University of British Columbia and B.C. Provincial Museum salvage expedition. Sections of this pole (catalogue nos. A50002 a,b,c) are now in the Museum of Anthropology.

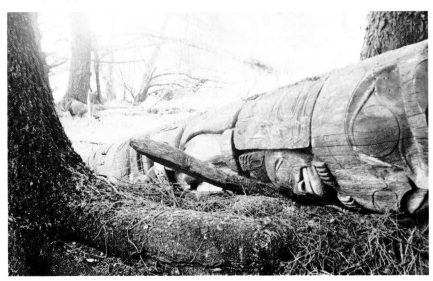

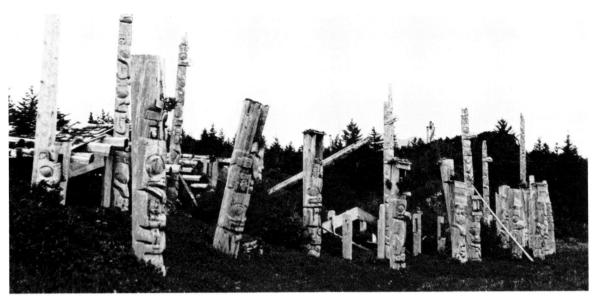

Figure 23. The deserted Haida village of Ninstints in 1901.

What was destroyed here was not just a few hundred individual human lives. Human beings must die anyway. It was something even more human—a vigorous and functioning society, the product of just as long an evolution as our own, well suited to its environment and vital enough to participate in human cultural achievements not duplicated anywhere else. What was destroyed was one more bright tile in the complicated and wonderful mosaic of Man's achievement on Earth. Mankind is the loser. We are the losers.

Wilson Duff Report of the B.C. Provincial Museum for 1957

The elements of Northwest Coast culture just discussed received their most spectacular artistic expression in totem poles carved during the early and middle years of the 19th century. Early trade with Europeans brought sudden and large increases in wealth; as a result, status rivalries and potlatching also increased, and, as a consequence, artistic production flourished. More and taller totem poles were set in place on the beaches, especially during the first half of the 19th century, and masks and other ritual objects were in constant demand. This brilliant outburst of art and culture, for which the Northwest Coast has become widely known, was not destined to last very long. Trade in furs declined, but not before Indians had become dependent on a monetary economy and exposed to the white man's diseases. Death and poverty reduced the population to a quarter of its original size within a span of a hundred years or less. By the 1880s many coastal villages were deserted, their few

survivors collected around missions, trading posts, or centres of employment. Stately poles were left behind to fall and decay, or to be looted by whites; other possessions were burned, sold, or lost. Ironically, this devastation of Northwest Coast art and culture was brought about by the same forces let loose by the coming of the Europeans that had earlier contributed to their short and brilliant efflorescence.

Northwest Coast Indian culture reached a low ebb in the 1920s and 1930s, except in Southern Kwagiutl villages where strong artists continued to produce fine pieces for traditional purposes. Elsewhere the art virtually died, although model totem poles and other curios, nondescript in style and poor in workmanship, were made for tourists. However, since the 1950s a new generation of artists has emerged, creating vigorously evolving new styles based upon the old traditions.

15

What is a Totem Pole?

Totemism. "Totem pole" is the name given by Europeans to the carved wooden pillars made by Indian peoples of the Northwest Coast. While the concepts "totem" and "totemism" have been applied to widely varying beliefs and practices among many different peoples, anthropologists now use them to refer to a symbolic relationship existing between natural phenomena (usually animals, but also plants, celestial bodies, landscape features, and so on) and human groups. The basic idea is that *differences* existing in nature are used to stand for or to identify *differences* among people, usually different groups of kin. Totemism is therefore essentially a system of classification. Just as bears differ from wolves or eagles, so do the people of Group A (whose totem is the bear) differ from those of Group B (whose totem is the wolf) and Group C (whose totem is the eagle). This does *not* mean that the people of Group A consider themselves *like* bears, or to have bear characteristics. When the Northwest Coast Indian says, "I am a Killerwhale", he means that he belongs to a kinship group which has a legendary relationship with the killerwhale. He is making a statement about his group membership.

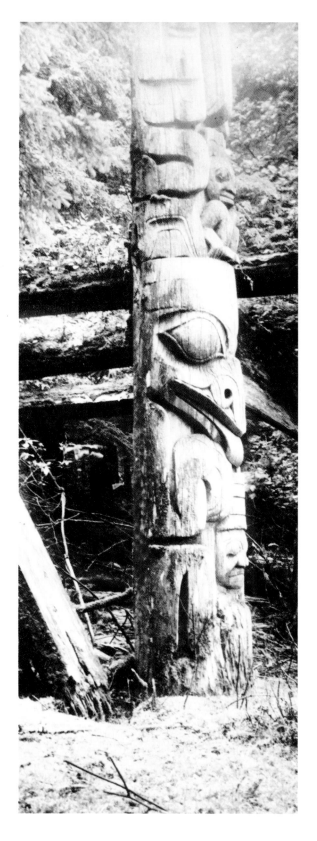

Figure 24. Haida house frontal totem pole from the last house to be built at the deserted village of Tanoo (catalogue nos. A50000 a,b,c,d). The principal crest on this pole is a bear, with human figures above and below.

16

Totem Poles. Similarly, the figures on a totem pole are primarily visual statements about the group membership and identity of those who erected them. On the Northwest Coast, totemic symbols can properly be called *crests*. The beings represented on totem poles, usually in animal form, are those beings from mythical times who became, or were encountered by, the ancestors of the group that later took them as crests. Thus, some Kwagiutl families claim as a crest the Thunderbird who descended from the sky to take off his animal clothing and become their human ancestor. Others claim crests on the basis of encounters their ancestors had with such beings as the powerful and wealth-giving *Sisiutl*, or Double-Headed Serpent. Rich and important families claim many crests, and related families claim crests in common.

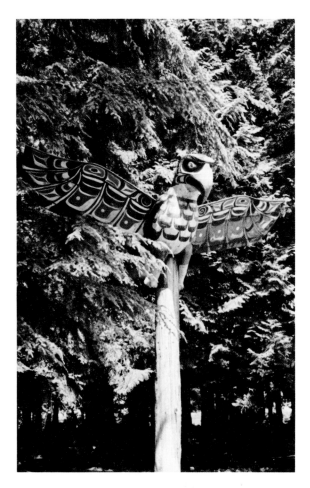

Figure 25. Southern Kwagiutl eagle crest totem pole from the village of Fort Rupert on northern Vancouver Island (catalogue no. A50042).

Figure 26. Southern Kwagiutl feast dish in the form of a Sisiutl (double-headed serpent); notice that the Sisiutl's tongues are removable ladles (catalogue no. A4147). Wheels were unknown to native culture prior to European contact.

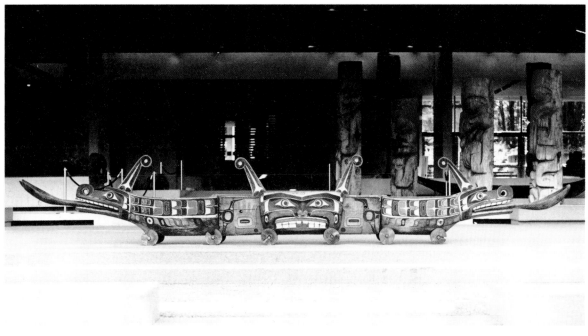

Totem poles were usually erected at potlatches, at which times the stories pertaining to the crests they displayed were told, and the right of the family to claim the crests was publicly witnessed. Especially important totem poles were those raised in honour of chiefs by their successors. When a totem pole was commissioned, the artist was told which crests it was to show, but there is considerable evidence that he was given freedom in how he chose to portray them. It appears also that the artists put into their designs hidden meanings and visual puns of their own. The meaning of a totem pole was, therefore, very personalized: to know exactly what a totem pole signified it would be necessary to ask both its owner and the carver what they had intended it to mean. Recorded information of this kind is surprisingly meagre, so that we only know the meanings of totem poles in the most general and, thus, superficial ways. Most of their meanings have died with the people for whom and by whom they were carved.

Totem Pole Types. Totem poles were erected for different reasons and as different kinds of freestanding and architectural forms. The main types of poles were the following:

House Posts — carved posts supporting the main beams of a house;

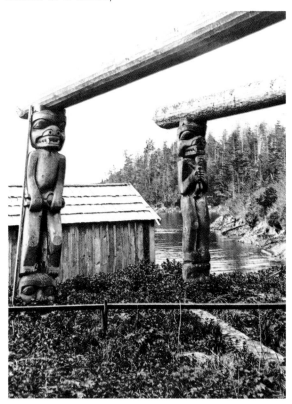

Figure 27. Southern Kwagiutl house posts at Xumtaspi Village on Hope Island in 1913. The post on the right is now in the Museum of Anthropology (catalogue no. A50007c; see also Figures 71, 72 and 73).

(on facing page)

Figure 28 (top). View of a Southern Kwagiutl house frame in its original setting at Quattishe, a Koskimo village on Quatsino Sound in 1955 (catalogue nos. A50009, a,b,c,d,e,f).

Figure 29 (left). The human figure house post has a whale on its chest and coppers on its arms. The platform is supported by two slaves and was used to seat a high-ranking person.

Figure 30 (right). These two front house posts are sea lions holding a carved Sisiutl (double-headed serpent) cross-beam in their mouths.

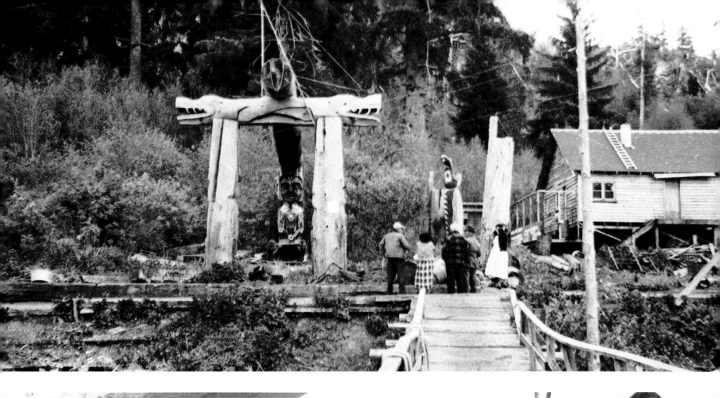

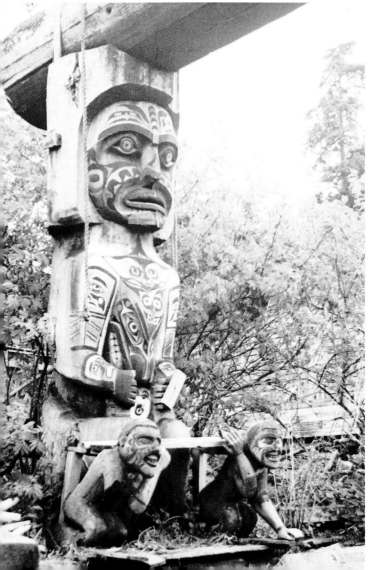

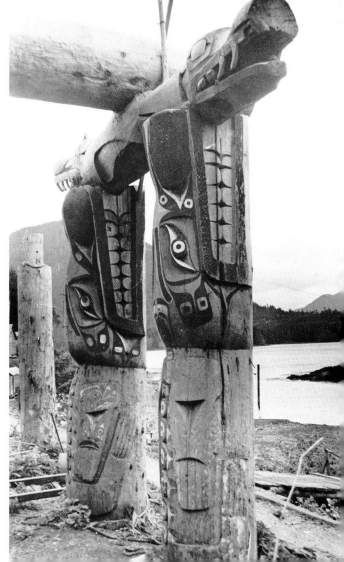

House Frontal Poles — poles standing against the front of the house, usually containing the opening through which the house was entered;

Figure 31. Oweekano (Northern Kwagiutl) house frontal totem pole from Katit Village, Rivers Inlet (catalogue no. A50006). The ceremonial entrance to the house is through the pole at left.

Memorial or Commemorative Poles — poles erected in honour of a person who had died, usually by the successor to his name;

Figure 32. Gitksan (Tsimshian) memorial totem poles at Kitwancool Village in 1910. The pole at left (catalogue no. A50019) is now in the Museum of Anthropology (see also Figures 59 and 60).

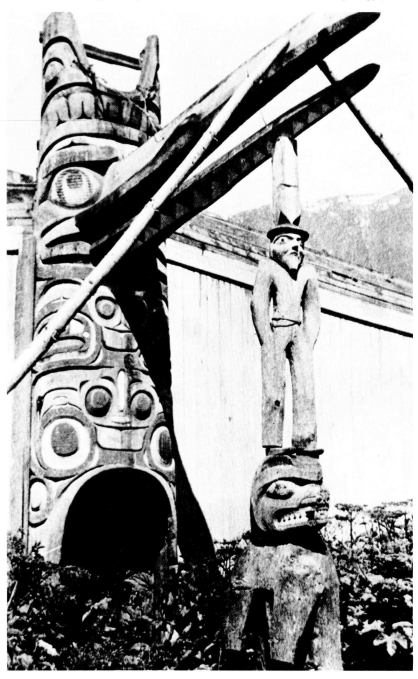

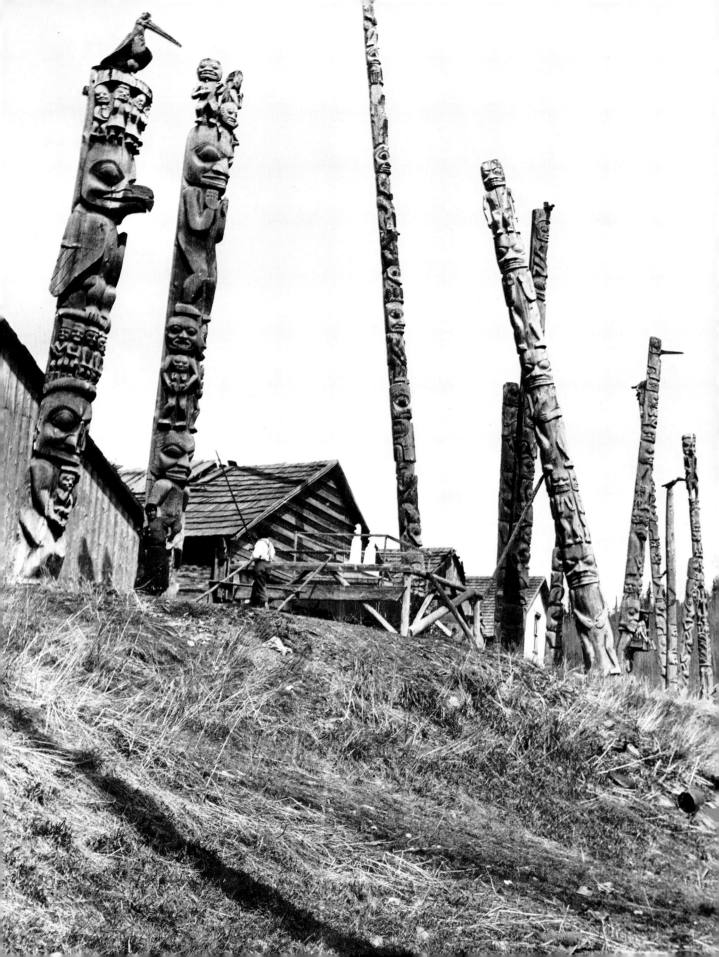

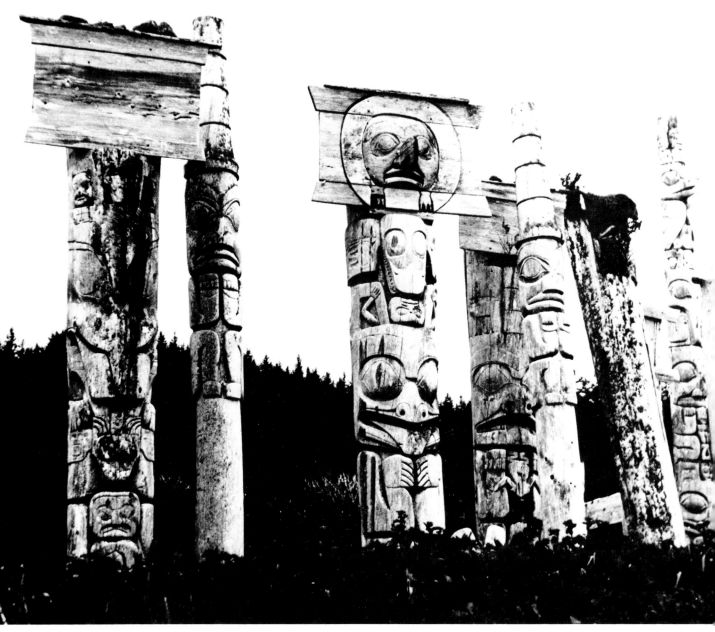

Mortuary Poles — poles containing the remains of the dead, usually in grave boxes incorporated into the pole;

Grave Markers — carvings placed where people were buried;

Figure 33. Haida mortuary totem poles at Ninstints Village. A Museum of Anthropology pole (catalogue no. A50017) is shown in the centre; the "hawk" or sunbird false box front was not collected.

Welcome Figures — carvings placed on the beach, as figures welcoming arriving guests coming by canoe.

Mortuary and memorial poles were usually placed in front of the houses of their owners along the beach. The tallest example known from the 19th century is a totem pole from the lower Nass River, now in the Royal Ontario Museum, which is more than 24 metres tall. Most poles, however, ranged between 3 and 18 metres. It has been estimated that totem poles seldom lasted as long as 100 years in the coastal climate, and their usual life before falling from wood decay was about 60 years. To move or restore a fallen pole required that its owner give another potlatch, and they were more usually left where they had fallen, sometimes to be revived at a later time.

Figure 34. Southern Kwagiutl welcome figures at the village of Blunden Harbour in 1901.

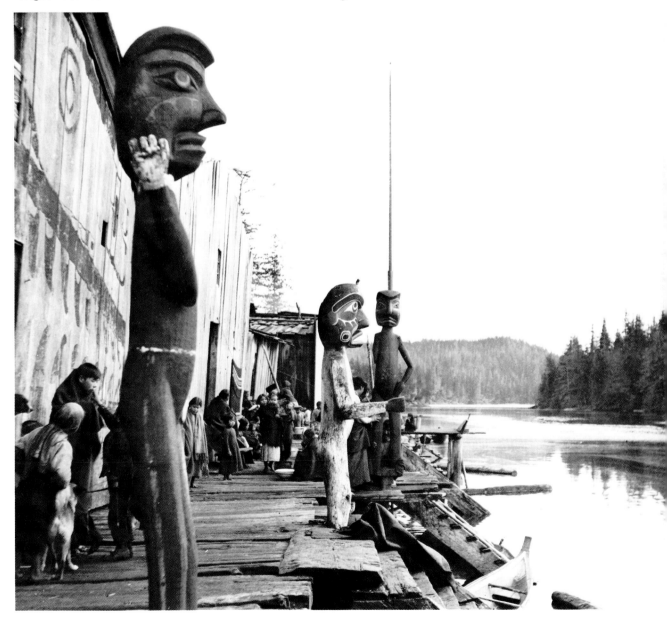

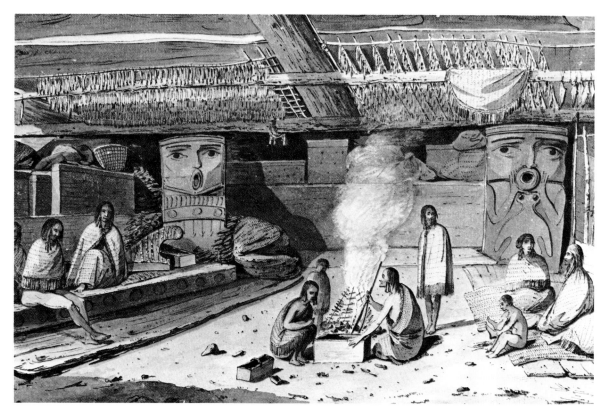

The Antiquity of Totem Poles. We do not know how long ago the first totem poles were carved on the Northwest Coast. Indeed, the major issue in the historical scholarship on totem poles has been whether or not they were present 200 years ago when the first European explorers arrived. Part of the problem has been semantic, in that writers about "totem poles" do not always specify to which of the types (house posts, frontal poles, memorial poles, mortuary poles, or grave and welcome figures) they are referring. Marius Barbeau, whose two-volume book *Totem Poles* (1950) is the most extensive and best known work on the subject, argued that free-standing and frontal poles were not observed by the earliest explorers but resulted from the stimulus of European contact, notably the subsequent availability of metal tools in large numbers, which greatly facilitated the task of carving them. More careful reading of the explorers' journals and examination of the drawings of expedition artists have now refuted this view. There is no longer any question that free-standing and fron-

Figure 35. *Interior of a West Coast (Nootkan) house in 1778. Water colour by John Webber.*

tal poles were observed by the first European visitors to Haida and Tlingit (southeastern Alaska) villages. After a careful review of the evidence on both sides, Wilson Duff (1964:91) concluded that "totem poles were ... a well established feature of the precontact culture of the Northwest Coast."

On the other hand, it is widely agreed that the entire complex of carved columns underwent tremendous growth during the 19th century as all types became larger and more numerous and the practice of carving them spread to neighbouring groups. New tools and increased wealth from participation in the European economy led to more lavish and more frequent potlatches and stimulated the production of art of all kinds. There are even records of rivalries between chiefs as to who could erect the tallest poles.

24

Totem Poles Today. Except for those in the village of Alert Bay and on the upper Skeena River (at Kitwancool, Kispiox, Kitsegukla, and Kitwanga), few late 19th and early 20th century totem poles remain today in native settings or in native ownership. Most have fallen and rotted, but a few dozen have been preserved in museums. Significantly, however, new ones have been commissioned since the 1950s for museums, parks and international exhibitions. The first of these new totem poles were made for the Museum of Anthropology by Kwagiutl carver Mungo Martin, who was followed by Haida carver Bill Reid, assisted by Kwagiutl carver Douglas Cranmer. These poles (A50028, A50030, A50031, A50032, A50033, A50035, A50040) and the Haida dwelling and mortuary houses, also built in the traditional style by Reid and Cranmer, can be seen from inside the museum in visual conjunction with the old totem poles which inspired them. More recently, the museum erected a new house post (Nb.7.229) by Nishga artist Norman Tait, and a totem pole (Nb7.244) by the Gitksan artists of 'Ksan. These new totem poles and carvings are eloquent testimony that this magnificent art is coming back to life, as is the native ceremonial context within which it was first created. Since the late 1960s, totem poles are once again being erected in villages with attendant potlatches.

Figure 36. Southern Kwagiutl artist Mungo Martin of Fort Rupert repainting his own totem pole (catalogue no. A50037) at the Museum of Anthropology in 1949; he had originally carved and painted it in Alert Bay in 1902 (see also Figure 57).

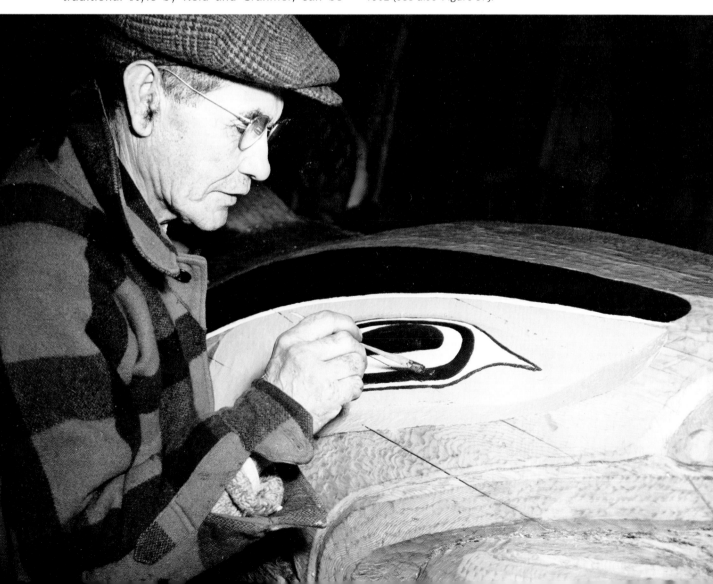

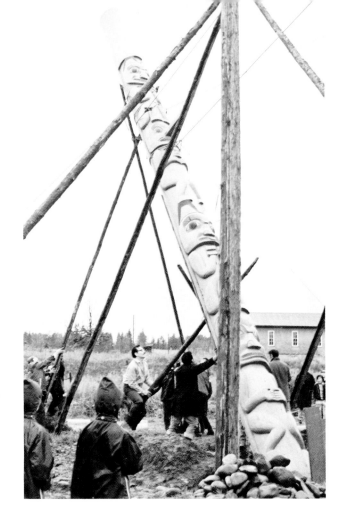

Figure 37. *Raising a modern totem pole carved by Gitksan (Tsimshian) artist Walter Harris at Kispiox Village in 1971.*

Figure 38. *Nishga (Tsimshian) artist Norman Tait restoring an old Nishga memorial totem pole (catalogue no. A50020) from Kwunwoq (see also Figures 56 and 76).*

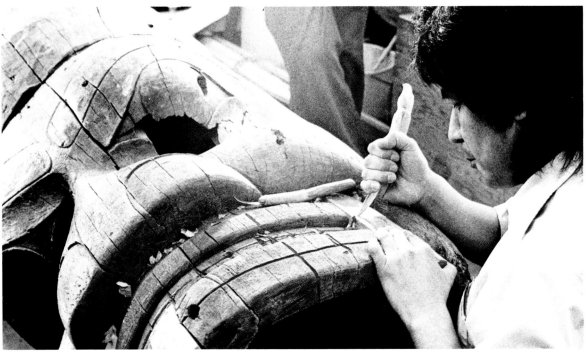

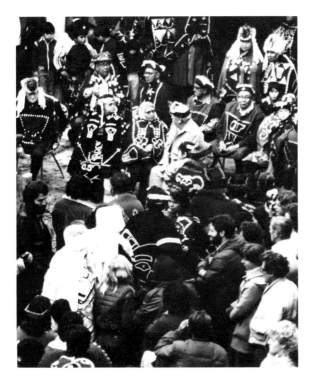

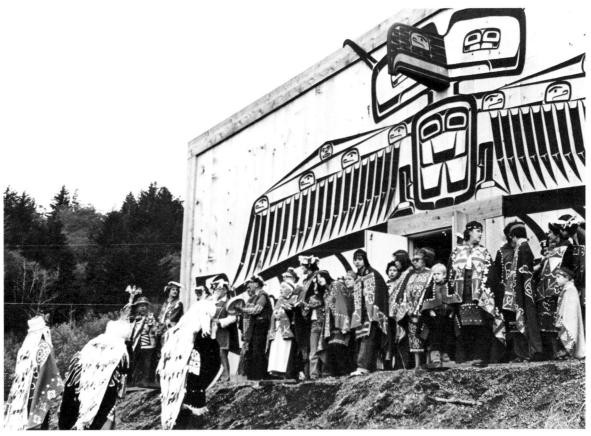

Figure 39. Guests join with Kwagiutl chiefs and elders to celebrate the opening on November 1, 1980 of the U'mista Cultural Centre at Alert Bay, B.C. The Kwagiutl have made special efforts to preserve their ceremonial and craft traditions.

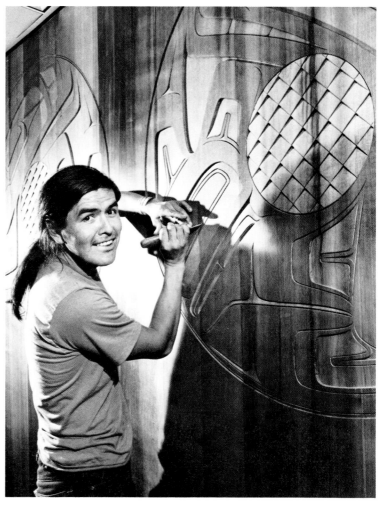

Figure 40. Haida artist Robert Davidson carving a cedar mural at the Vancouver offices of the Canadian Broadcasting Corporation in 1976.

Contemporary Sculpture. At the same time, new monumental sculptures are being created by native artists which are no longer totemic in meaning, but which clearly derive from the totem pole tradition. The first of these, a large carving of a Bear (A50045) by Bill Reid, and a Wasgo or Sea Wolf (A50029), by Reid assisted by Douglas Cranmer, are in the Great Hall of the Museum of Anthropology. These are single figures in the horizontal plane, rather than the vertical plane of the tree, and there are rare precedents from earlier times of similar forms used as memorial figures. More radical departures from the old forms are the great carved cedar doors at the entrance to the museum, created by master carvers from 'Ksan (a reconstructed village and carving school), on the upper Skeena River, and the wonderful Bill Reid sculpture, "The Raven and the First Men".

Most generally, we can say that the shift in form manifested by these works of sculpture reflects a shift in meaning from the totemic to the mythological content of native culture. Whereas totemic forms derive meaning from their local social context — that of clan and tribe — mythological themes reflect more universal dimensions of human experience. We have not yet attended sufficiently to the evolution of these new forms and the changed social and cultural contexts in which they are being created. Most experts are purists and tend to deplore the loss of traditional forms rather than to celebrate the creations of living artists.

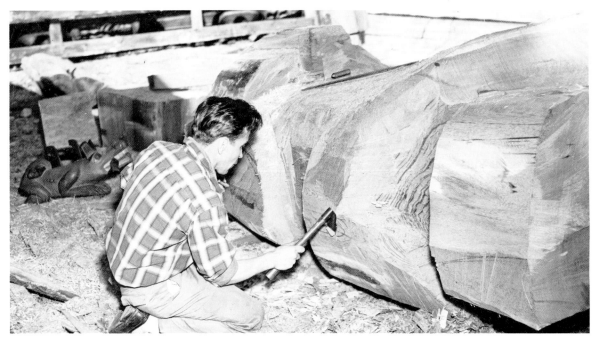

Figure 41. Southern Kwagiutl artist Douglas Cranmer carving the Museum of Anthropology's Wasgo (sea wolf) in 1962 (catalogue no. A50029). The smaller Wasgo on the left, from the collection of the B.C. Provincial Museum, is attributed to Haida artist Tom Price (c. 1860–1927). Modern sculptures are often copied from or inspired by older pieces in museums.

Figure 42. The great entrance doors of the Museum of Anthropology, carved by the master carvers of 'Ksan in 1976.

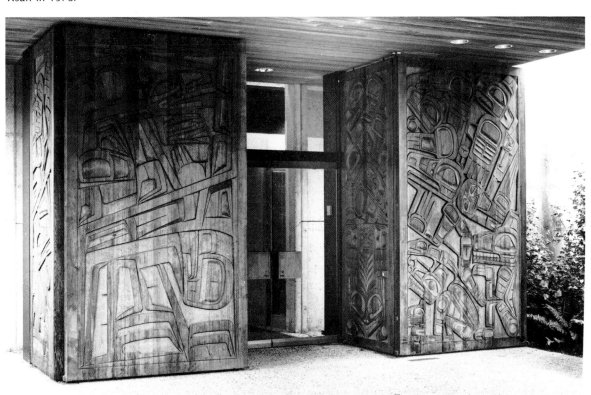

The time has come when we must actively choose how to consider these new sculptures. They are immediately recognizable as Northwest Coast art, yet both their form and their meaning have changed. Most evidently, we can see that the forms of contemporary sculpture are simplified and more realistic than the old carvings. There are more single figures now and few monstrous combinations of more than one life form in a single image.

Both simplification and realism facilitate cross-cultural communication. Most of the consumers — those who commission and purchase the art — are now non-natives. In order to communicate with the new consumers, the artists are creating forms which are more naturalistic, more universal. These forms contain fewer cultural messages, and their appreciation is less dependent upon mastering a complex and unfamiliar style. The social context of this art has recently shifted from the level of local consumption to the international art market. Not only is it now appreciated across Canada but also in the United States, Europe, and Japan as well. It is only from a narrowly conservative perspective that this can be considered a pollution of cultural purity or the creation of an art which has lost its meaning. These new forms are meaningful within a new and expanded cultural context. The mythological content of contemporary Northwest Coast art is actually more accessible to larger numbers of people than much of Western fine art, probably because of its preoccupation with the great theme of man's relationship to nature and because it touches ancient and universal archetypes such as the Trickster (which is discussed on the following page).

This is not to say that any or all innovations in contemporary Northwest Coast art are successful or that all of the current artistic experiments are to be applauded. Northwest Coast art is an extremely sophisticated aesthetic or stylistic tradition, and it is also a delicate one requiring long training, sensitivity, and integrity to master.

The tradition was almost lost entirely in the first part of the 20th century, and this could happen again. To prevent that, artists, collectors, curators, connoisseurs, critics — and the general public — should develop a high awareness and appreciation of the aesthetic tradition out of which the contemporary forms come. Museums have an important contribution to make here and should consider exhibiting not only the best of the past form, but also the worst. A single model totem pole made for the tourist trade in the 1930s (see Figure 43) can sometimes do more to create awareness of the fragility of traditional form than a whole gallery of masterpieces.

Figure 43. This poorly carved and painted model totem pole from the Nass River, circa 1930 (catalogue no. A8763), demonstrates the loss of cultural integrity.

The Raven and the First Men. Bill Reid's new sculpture illustrates the preceding discussion and awakens us to the creative potentiality contained in blending the ancient Northwest Coast tradition and the tradition of European naturalism, ultimately derived from the flowering of ancient Greek culture. Out of the tensions and contradictions of his own experience, Reid has created a magnificent artistic resolution.

Reid was born some sixty years ago of a Haida mother and white father. Raised entirely in the European culture of his father, Reid discovered Haida culture as an adult and is now acknowledged as the primary creator of the present artistic renaissance. He is accomplished in the media of silver, gold, wood, argillite, and the silkscreen print, having trained himself in the Haida tradition by studying old pieces in museums.

In 1970, he created a small (7cm) boxwood carving of the mythic incident in which the culture hero and trickster, Raven, discovered the first Haida men in a giant clamshell. When the Museum of Anthropology was being designed, museum patrons Walter and Marianne Koerner commissioned an enlargement of this piece, and architect Arthur Erickson designed a special rotunda to receive it. The resulting sculpture was carved from a laminated block of 106 yellow cedar beams by Reid and four other carvers — George Norris, George Rammell, and Haidas Gary Edenshaw and Jim Hart. It was unveiled on April 1, 1980, by the Prince of Wales and dedicated by representatives of the Haida villages of Massett and Skidegate on June 5 at a great feast attended by hundreds of museum members and friends. This acknowledgement by leaders of both Haida and European cultures alerts us to the special importance of this artistic achievement.

The constant, delighted response of museum visitors who daily encounter the carving testifies to its power to touch our emotions. Scholars

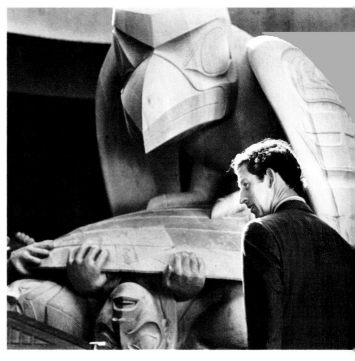

Figure 44. H.R.H. Prince Charles unveiled Bill Reid's monumental sculpture, "The Raven and The First Men", at the Museum of Anthropology on April 1, 1980.

have speculated that the Trickster is the oldest surviving mythological theme in the human experience. It may be that Raven touches the deepest aspects of who we are. Speaking of another native North American Trickster figure, the anthropologist Paul Radin once wrote that he "is everything to every man — god, animal, human being, buffoon, he who was before good and evil, denier, affirmer, destroyer and creator. If we laugh at him, he grins at us. What happens to him happens to us."

Reid's newly awakened humans appear to be simultaneously infants facing life and old men facing death. Two of them are climbing back into the darkness of the shell, while the others look out at the world, and at us, in wonder, fear, and awe. In the attitudes they express, we can each find the mirror that suits us best.

When we compare their faces with the traditional faces of Northwest Coast art shown elsewhere in this guide, we can see that what Reid has added from the Western tradition are emotion and individuality. When we consider the carving as a whole, we see that he has brought "The Raven and the First Men" into the dimension of Time — the myth has become historical.

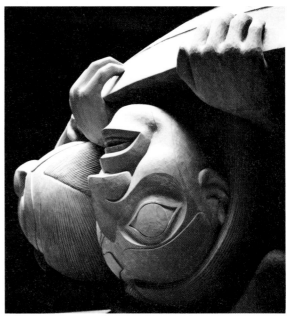

Figure 45. Bill Reid and views of "The Raven and The First Men" [catalogue no. Nb1.481].

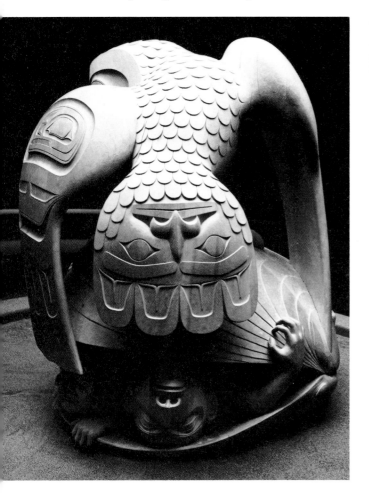

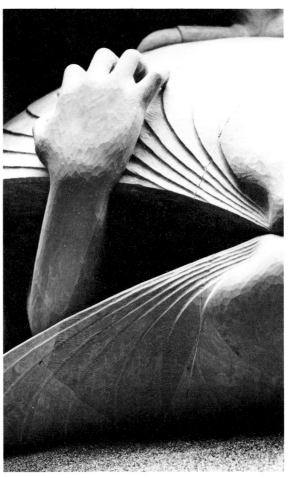

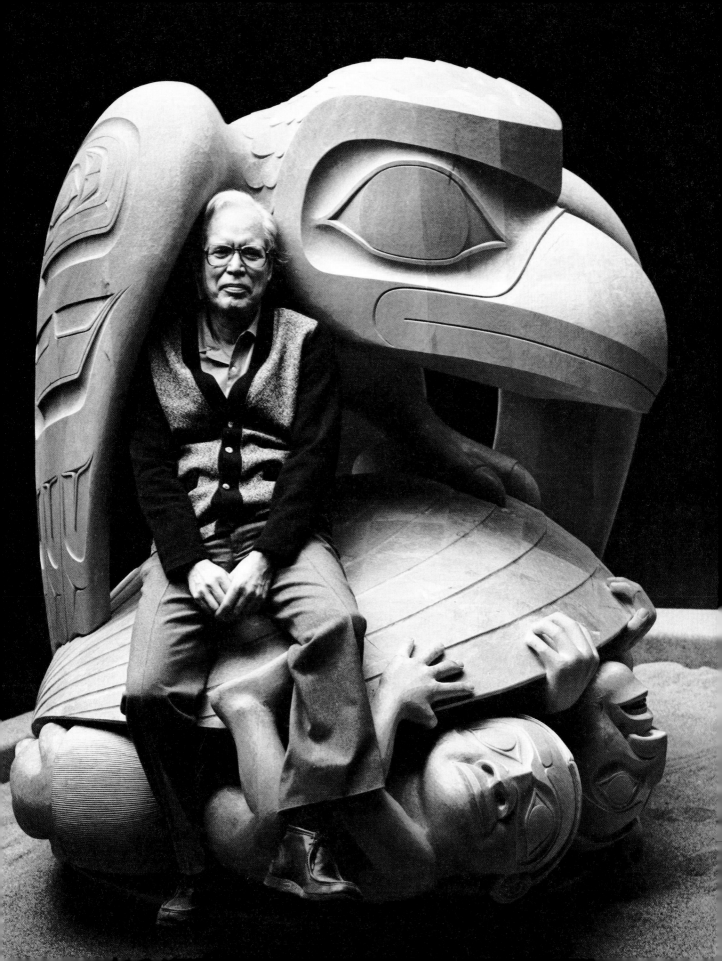

Suggestions on How to Look at Totem Poles

There are at least three ways to look at totem poles.

1. **The Skill of the Carver**. Most Westerners tend to think of so-called "primitive" art as being produced by anonymous, faceless people who are simply the human vehicles through which artistic forces within a culture are expressed. In our own culture, on the other hand, we emphasize individual expression and recognition and tend to regard artists as exceptionally sensitive and creative people who express personal or even idiosyncratic visions of their own inner conflicts and their perceptions of a changing world. In reality, the unknown Indian carver, too, was a unique individual creating personal artistic statements within a tradition or set of rules governing the creation. The artistic traditions of the Northwest Coast have been slower to change than our own and the rules somewhat more constraining, but within these limits the carvers created personal statements and found their own solutions to artistic problems. Some of these carvers achieved considerable fame for their work — Charles Edenshaw and more recently Mungo Martin and Bill Reid may serve as examples.

Northwest Coast art is pre-eminently an art of line, and attention to the carver's control and use of line can help to reveal his skill. There are two kinds of line to look for — pure and emergent. Pure line is two-dimensional line, whether painted or carved in low relief; emergent line, which is especially clear and beautiful in Haida sculpture, is line formed by the intersection of planes. With both we can learn to appreciate superbly controlled movement. The best way to let the eye learn to follow line in Northwest

Figure 46. A superb example of pure or painted line on a northern chief's chest (catalogue no. A8211).

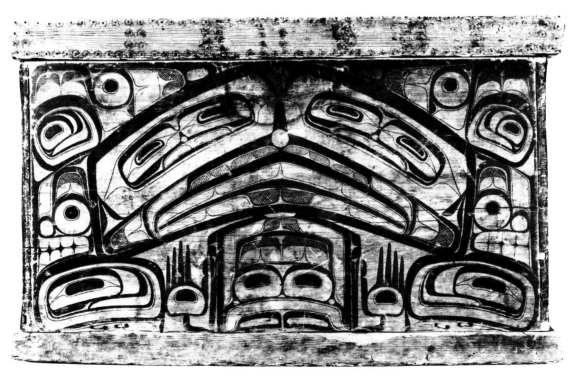

Coast art is to look at the carved and painted designs on the fronts of boxes and chests. The Haida artist Bill Reid once wrote of these designs: "The basic lines of a box design start with a major image, rush to the limits of the field, turn back on themselves, are pushed and squeezed towards the centre, and rippling over and around the internal patterns, start the motion again. Where form touches form the line is compressed, and the tension almost reaches the breaking point, before it is released in another broad flowing curve" (Duff, with Holm and Reid, 1967). Having seen such strong two-dimensional or pure line on boxes and chests, you can begin to look for more subtle expressions of line in sculpture.

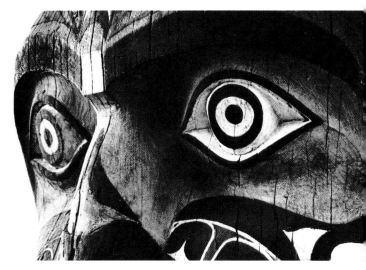

The most characteristic form in Northwest Coast design is called an ovoid, a particular oval shape (although it sometimes approaches a circle) which varies in its proportions while retaining its basic form. Ovoids are major design elements on boxes and chests, and in sculpture they are commonly found as eyes and at limb joints. Beautifully formed ovoids which seem, especially at their corners, to contain great tension are regarded as especially definitive clues to the better artists, while sloppy or loose ovoids are characteristic of poor artists. Ovoids sometimes have smaller ovoids in their centres, and the range of

Figure 47. A combination of pure and emergent line on a Haida totem pole from Skedans (catalogue no. A50002b). The eyebrows are incised pure line; the eyesocket is emergent line formed by the intersecting planes of the eye cavity and the surrounding face (see also Figure 22).

Figure 48. Pure and emergent line on a Southern Kwagiutl (Koskimo) house post (catalogue no. A50009c) from Quatsino Sound (see also Figure 29). Painted or pure line and emergent line coincide in the bottom of the eyebrow.

Figure 49. A complex inner ovoid elaboration carved in shallow relief on a Northern Kwagiutl (Oweekano) frontal pole (catalogue no. A50006) from Rivers Inlet (see also Figure 31). A smaller and more circular ovoid intersects with the larger one at the upper right.

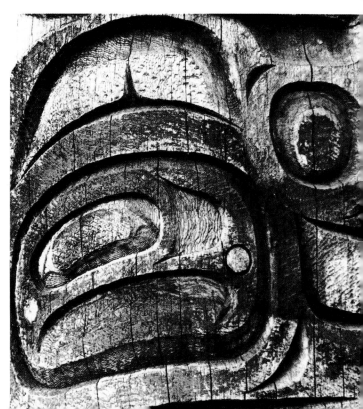

elaborations and variations is quite large. It can be a pleasure just to seek them out and enjoy the way Northwest Coast artists play with this basic form.

Another design feature which can be pleasurable to look for and compare in different carvings is the unexpected combination or juxtaposition of visual elements, which often seems to have been humorous in intention. This has been called visual punning. Common puns are the use of a part of one creature to form the whole of another or the placement of one creature in unexpected parts of another. For example, human faces are often found in the ears of bears and in the tails of beavers or wearing the tail feathers of birds as head-dresses.

Totem poles are usually composed of a series of major figures arranged vertically along the columnar pole. In Haida poles especially, small figures are also common, coming out of ears and mouths, on the major figure's head and between its legs. The ingenuity with which the minor figures are incorporated into the design is another feature to look for.

Northwest Coast art is essentially an applied art, in that the design is applied to an already existing form, whether it be a spoon handle, box, bowl, or totem pole. One of the major variations in totem pole carving (which will be discussed again under "Differences in Cultural Styles") is the degree to which the cylindrical form of the tree is maintained or ignored in applying the sculptural forms. You can begin to look for this early in your appreciation of totem poles and then return your attention to it when learning the differences in various styles.

Figure 50. A small upside-down human's arms come out of a bear's ears on a Haida totem pole (catalogue no. A50017) from Ninstints (see also Figure 33).

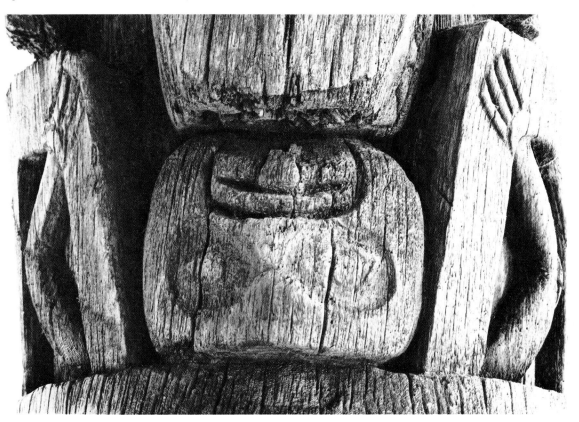

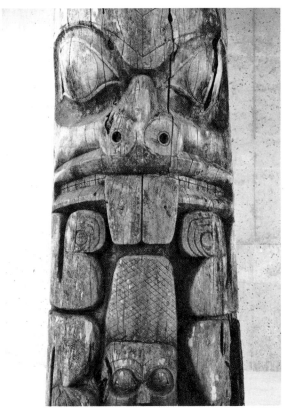

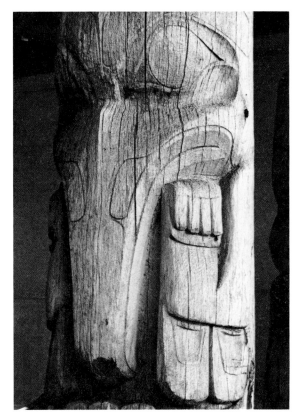

Figure 51. The beaver on this pole from the Haida village of Ninstints can be recognized from its cross-hatched tail, large incisor teeth, and paws holding a chewing stick (catalogue no. A50013).

Figure 52. Transformation of a bird's wing into a human arm on a Haida totem pole (catalogue no. A50000c) from Tanoo Village (see also Figure 24).

2. **Recognizing Life Forms.** Totem pole figures are usually life forms — humans, animals, birds — although also common are invented forms in which attributes of several different life forms are combined. The most popular way of looking at totem poles is to attempt to recognize natural forms from certain stylized clues usually (but not always) contained in them. Thus, for example, the beaver normally has a cross-hatched tail, large incisor teeth, an open mouth, and a chewing stick. The killerwhale can usually be recognized by its dorsal fin; the bear by a protruding tongue, large clawed feet, and a lack of tail; the wolf by a long snout and a long tail; the raven by a strong, straight beak; the cormorant by a longer beak than other birds; the eagle by a down-turned tip to its beak; the frog, also tailless, by a wide toothless mouth, and so on.

Even more rewarding, however, is to look for signs of transformation. Although many of the life forms represented on the poles are birds and animals, most of them are sitting, standing, or kneeling in the manner of humans, suggesting that the human body is the basic form in the art. This is also true of faces, since the placement of eyes, nose, mouth, and chin in animals is essentially human. When we remember that in legendary times various forms of life were interchangeable and that animals could become human by taking off their skins, we can begin to glimpse the meaning behind this feature of the art. An especially clear transformation can be seen in the cormorant figure on a Haida pole (A50000c), which has humanoid legs and arms with feathers attached.

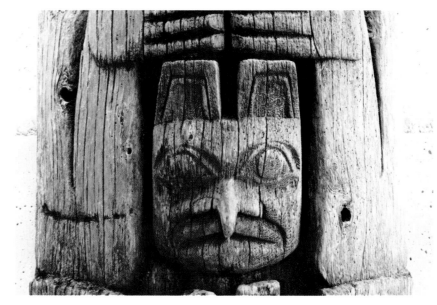

Figure 53. A small face on a Haida house post (catalogue no. A50016) from Ninstints combines animal ears, bird's beak, and human mouth and nostrils (see also Figures 80 and 81).

Attention to hands and ears can also help the viewer find transformations. For example, a small face on a Haida totem pole section (A50016) seems essentially human, especially in its mouth, but it also has animal-like ears and a recurved beak. Hands on animals and humans range from claws to human hands with fingernails. The more carefully we attend to such details as these, the more difficult it becomes to say with any certainty what life form is represented in the sculpture. As this certainty disappears, we begin to appreciate the deliberate ambiguity inherent in many of the forms. We are then perhaps coming closer to the intended meanings of the sculpture, which are to take the viewer back into the past when all these things were possible and when beings could flow from one form into another. Thus we could even say that the life forms depicted on poles and other sculptures are not static or fixed but fluid, caught in the midst of a transformation. Movement through transformation of form is very much a part of Northwest Coast symbolism, in myth as well as art.

Related to transformations are reversals, in which the normal relationship between an animal and a man is reversed. Although we cannot know exactly what the carvers intended,

Figure 54. Detail from a painted chief's chest (catalogue no. A8211) shows human hands belonging to a stylized spirit animal (see also Figure 46).

there are two similar sculptures, one Kwagiutl (A50007c) and one Haida (A50002a), in which a bear is holding a small human, perhaps a corpse, which might suggest a reversal of the normal relationship between man the hunter and animal the hunted. Such interpretations can only be conjectures, however, since the intentions of traditional carvers were never recorded, and most contemporary carvers are reluctant to discuss their work in any detail. But even though there is usually no way we can test our interpretations against the actual intentions of the artist, we can at least allow ourselves to visually "surrender" to the forms and let our imaginations play with them.

Figure 55. A Haida totem pole section from Skedans (left; catalogue no. A50002a) and a Southern Kwagiutl house post from Hope Island (right; catalogue no. A50007c) show a similar motif, a bear holding a human.

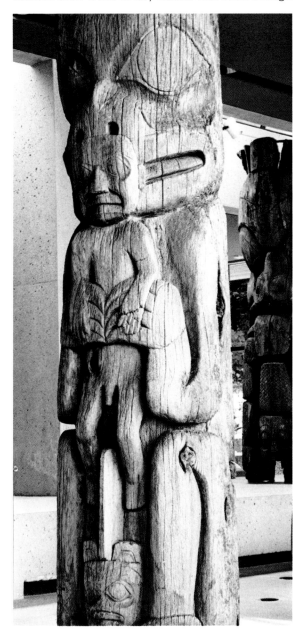
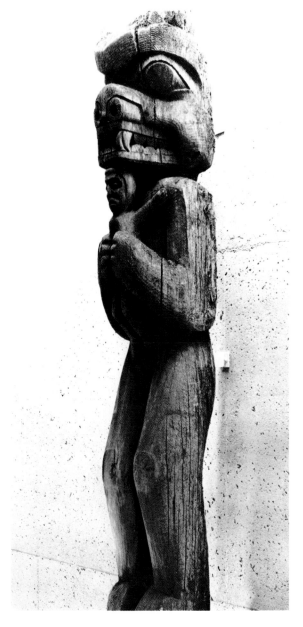

3. **Differences in Cultural Styles**. Experts and connoisseurs frequently compare differences in stylistic features of the art of cultural groups on the Northwest Coast and assign undocumented objects to a particular group on the basis of such features (just as they do with unsigned works of art in our own or any other artistic tradition). In recent years, the identification of stylistic features has been refined to the point that specialists are beginning to recognize the work of particular artists (see Holm, 1974). Learning cultural styles on the Northwest Coast can be an especially good way to appreciate both the strength of artistic traditions and the innovations of particular artists working within them.

If the artists had simply arranged realistic life forms in vertical progression up a tree trunk, this kind of exercise would be impossible. Although they did have the ability to carve realistically (as any number of masks and other small pieces attest), some of the traditions within which they worked contained rules according to which life forms were stylized or abstracted from nature in specific ways. There were other rules governing their placement on poles, as well as the degree of the sculptural quality (the relative depth or shallowness of the carving) imposed on the form of the tree. Thus, the Haida of the Queen Charlotte Islands barely sculpted their totem poles at all. The design is essentially a two-dimensional one in low relief which looks as if it had simply been wrapped around one half of the tree trunk, barely affecting its original cylindrical shape. Few recessed or projecting shapes can be found. The beaks and wings of birds and the snouts of animals turn downwards, flattening into the tree. Also, as on the front of a carved box, the Haida carver left few blank spaces in his design. By contrast, their neighbours on the mainland, the Tsimshian, increased the sculptural quality of their poles to an easily recognizable extent. Birds have projecting beaks, humans have projecting arms (A50020), and the carving in general is cut more deeply into the wood.

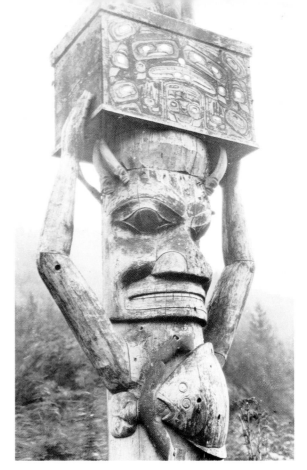

Figure 56. A shaman figure on a Nishga memorial pole (catalogue no. A50020) illustrates the general style of the Tsimshian groups. The shaman has a halibut with a human emerging from its mouth on his abdomen and is holding a chief's chest, which became separated from the pole before it was collected for the Museum of Anthropology, and has since been discovered at another museum (see also Figure 76).

Moving south to the Kwagiutl-speaking peoples of northern Vancouver Island and the adjoining mainland, one finds the sculptural quality of the poles becoming even more pronounced. Beaks jut strongly forward, and wings flare out widely. Figures are more naturalistically carved in the round, and the original shape of the tree in many instances seems to have been ignored altogether.

Figure 57. Southern Kwagiutl poles, such as this one at Alert Bay (catalogue no. A50037) carved by Mungo Martin in 1902, show a pronounced sculptural quality (see also Figure 36).

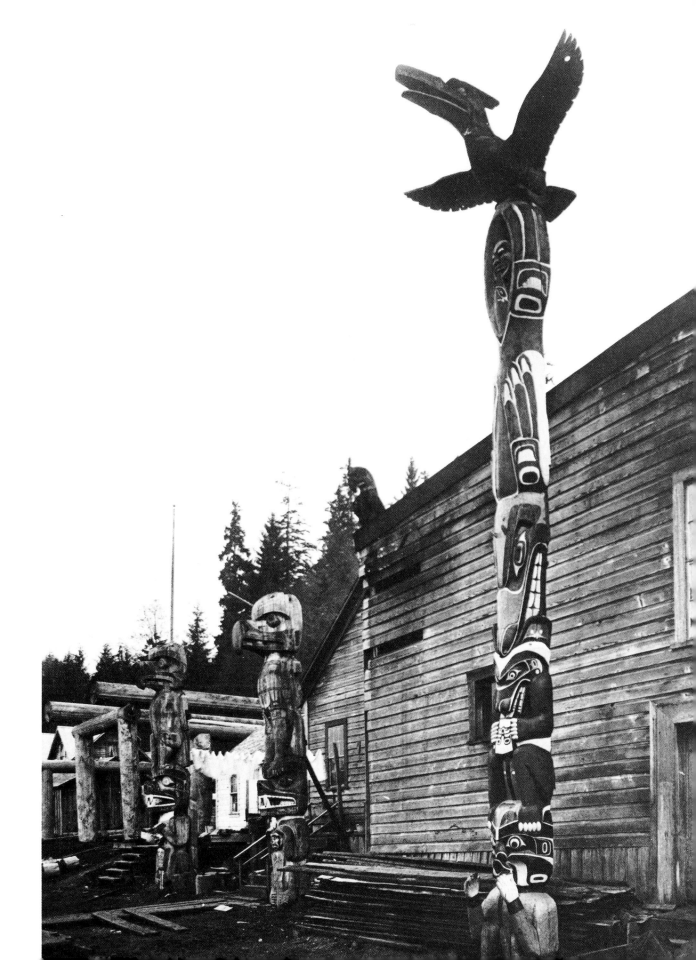

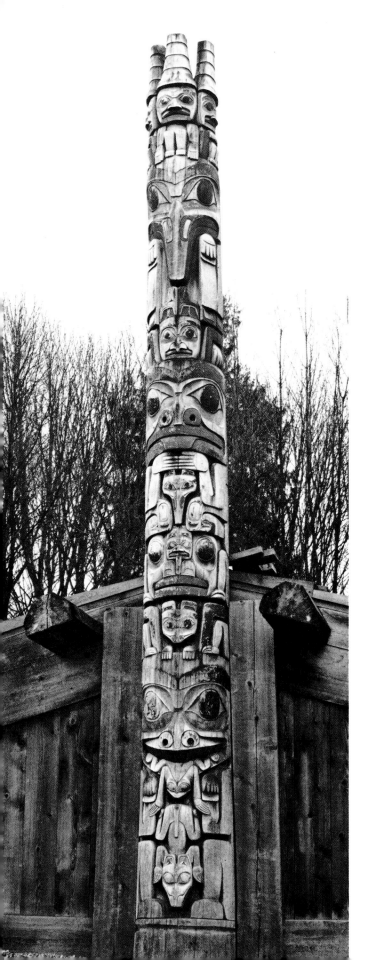

Posture is a reasonably consistent feature in Haida and Tsimshian poles, especially when contrasted with those from the south. Northern pieces commonly show figures — human, animal, and bird — with knees and elbows almost touching, while those of the Kwagiutl exhibit more diversity in their arrangements of arms and legs. An even more diagnostic feature of the figures is the size of the head in proportion to the body. On Haida poles, the head and body are roughly the same size, or in a proportion of 1 : 1. On Tsimshian poles the body is twice the size of the head, the proportion of head to body being 1 : 2. On Kwagiutl poles the head and body proportions are more naturalistic, approaching those of humans.

Figure 58. A modern house frontal pole (catalogue no. A50030) by Bill Reid, assisted by Douglas Cranmer, shows the complex intertwining of figures characteristic of the Haida Style (see also Figure 79).

Figure 59. A row of minor figures creates a break between major figures on a memorial totem pole (catalogue no. A50019) from the village of Kitwancool, illustrating a characteristic of the Tsimshian style (see also Figure 60).

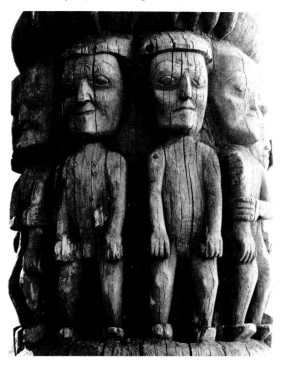

Another distinctive feature in totem pole styles lies in the nature of the horizontal separation of major figures. This is a particularly good feature for distinguishing Haida poles from Tsimshian. The Tsimshian carver usually created a strong horizontal break or line between major figures, with no overlapping details or minor figures interspersed. The eye has no difficulty at all in separating the figures or finding where one ends and another begins. The Haida, on the other hand, commonly intertwined figures so that they are difficult to separate from each other. The complex overlapping of the raven, upright human, whale, and inverted human on the middle section of a Haida house frontal pole (A50001), with one form flowing into the next, is typical of Haida carving. It is thus more challenging to identify the figures on Haida poles, making certain that you have put together all the correct arms, legs, ear, fins, wings, etc., of each one. Kwagiutl poles normally have horizontal breaks similar to those of the Tsimshian.

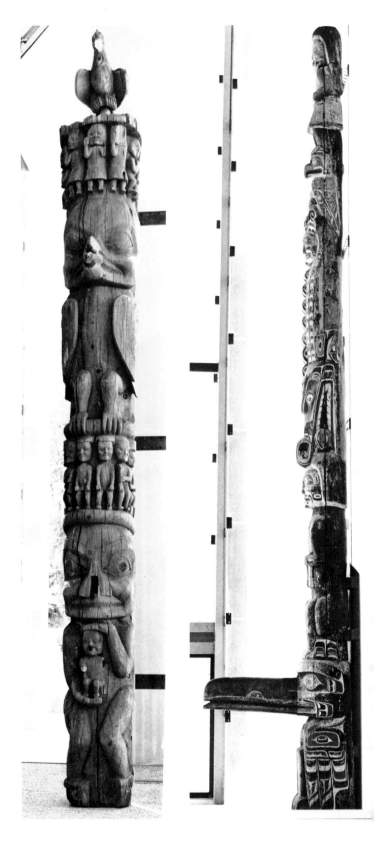

Figure 60 (left). A memorial totem pole (catalogue no. A50019) from the village of Kitwancool, a Gitksan (Tsimshian) village noted for its totem poles. When this pole was acquired for the Museum of Anthropology, a copy was made for the village.

Figure 61 (right). Figures on a Southern Kwagiutl memorial totem pole (catalogue no. A50038) from Fort Rupert can be easily distinguished.

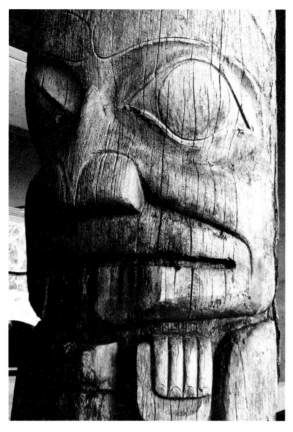

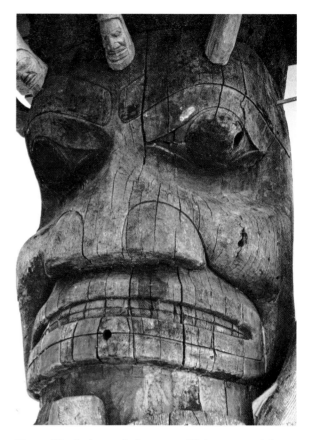

Figure 62. A woman's face on a Haida totem pole section (catalogue no. A50002c) from Skedans (see also Figures 22 and 77). Her labret, an ornament worn through an opening in the lower lip, is missing.

Figure 63. A shaman's face on a Nishga memorial pole (catalogue no. A50020; see also Figures 56 and 76).

Connoisseurs are especially attentive to human or human-like faces on totem poles as indices of stylistic differences. While these are obvious to the trained eye, they are somewhat subtle and difficult to capture in words (see Holm 1972: 79–82 for careful and precise descriptions of the facial renderings of different styles). The Haida face, like the rest of Haida pole carving, is barely sculpted into the cylinder of the tree trunk; its forehead rises quite straight up from the brow, the nose is flat and broad and presses down toward the mouth. The eyesocket is normally a beautiful ovoid in form, with a slightly protruding orb. Especially distinctive is a carved ridge outlining the eye itself. The resultant line as the eyesocket meets the cheek and the brow is clear and sharp.

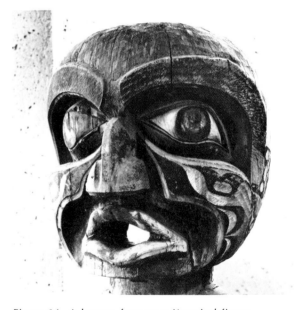

Figure 64. A human face on a Kwagiutl figure (catalogue no. A50043) from Blunden Harbour.

The Tsimshian face is similar, although some-
what more realistic, its surface suggestive of
taut skin over skeletal structure. The eyesockets
are less ovoid, their orbs are more protruding,
and the eyes lack the raised outlining line of the
Haida eye. The cheeks tend to have a pronounced
bulge. The mouth is wide with thin lips, and the
chin is short. There is more of a backward slope
to the forehead, and the carving in general is
deeper.

The Kwagiutl face is deeply carved with sharply
intersecting planes in place of the curves of a
real face. The orb is pronounced, often cone-
shaped, with the eye painted and/or carved in its
centre. The lips protrude. The sculptural lines of
the face are often emphasized by painting.

The house post shown at right (A50003), present-
ly in storage and awaiting recreation at the
Museum of Anthropology, is typical of Coast
Salish large sculptures. Its face is essentially flat,
with small eyes set back under a projecting
brow. The hat-like form above the head is
typical, as is the body carved in simple, strong
lines. Comparison of the photograph of this
piece with the displayed Coast Salish carvings of
humans on the next page shows little similarity.
The grave figures (A1780, A1781) are more
sculptural and expressive than normally found,
and the man facing the bear (A50004) is more re-
alistically rendered.

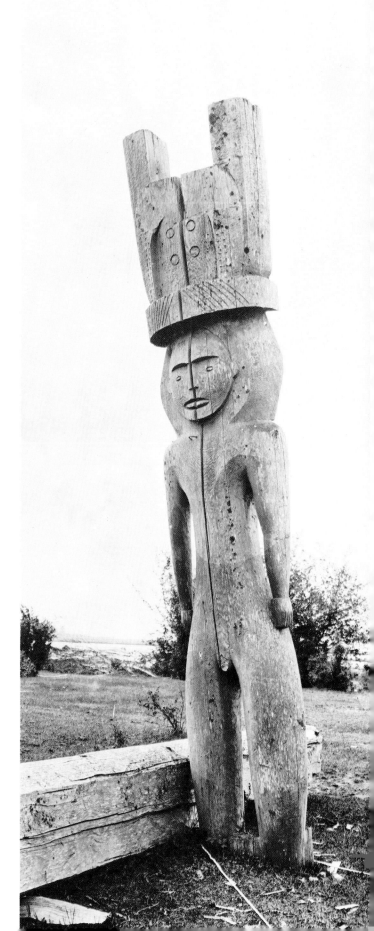

*Figure 65. Coast Salish house post (catalogue no.
A50003) at Musqueam Village in 1898.*

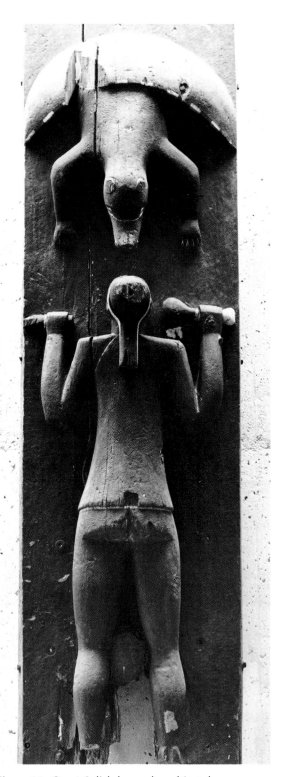

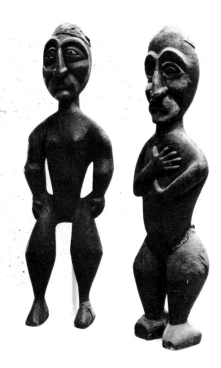

Figure 67. Human figures (catalogue nos. A1780, A1781) found in the Fraser River near Sardis, attributed to the Coast Salish.

Figure 68. Detail from one of three Coast Salish house boards (catalogue nos. A50005a,b,c) from Quamachan with unidentified animals, possibly of the Mustelidae family (minks, otters, fishers, etc.).

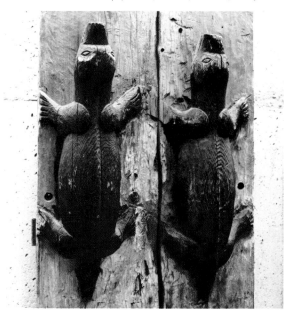

Figure 66. Coast Salish house board (catalogue no. A50004) from Musqueam shows a hunter holding a knife and rattle facing a bear coming out of a cave.

Figure 69. Bella Coola Village in 1909.

Figure 70. West Coast (Nootkan) house post at a Clayoquot Sound village in 1903.

The principles of examining totem poles outlined in this book are designed to increase enjoyment of these powerfully evocative pieces and appreciation of their creators. The rules presented here were not derived from scientific analysis (for this has not yet been done) but from more sustained study than most museum visitors have time for. With the preceding suggestions in mind, individual viewers may formulate refinements and extensions of the totem poles' significance and enjoy for themselves the personal satisfaction of doing so.

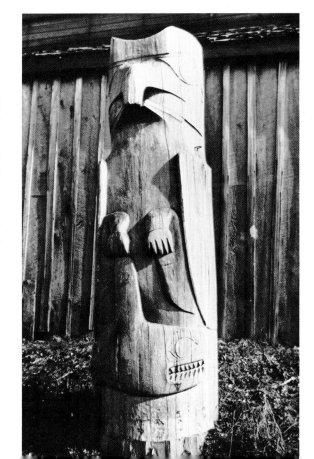

List of Totem Poles and Other Large Sculptures on Display in the U.B.C. Museum of Anthropology and on its Grounds

(Most of the older sculptures displayed at the Museum of Anthropology were acquired through purchase in the 1950s by the Totem Pole Preservation Committee, established by the U.B.C. Museum of Anthropology and the British Columbia Provincial Museum. The expeditions by this committee to rescue endangered poles were greatly assisted by Walter C. Koerner and H.R. MacMillan, both of whom also supported restoration work and the carving of many of the newer poles in the Museum of Anthropology's collection. Additional information on this period is provided in the Museum's two catalogues, *Indian Masterpieces from the Walter and Marianne Koerner Collection* and *Northwest Coast Indian Artifacts from the H.R. MacMillan Collections*, both published by the University of B.C. Press.)

Nineteenth and Early Twentieth Century Carvings

Coast Salish

1. Human Figures from the Lower Fraser River (A1780, A1781), Gallery I.
2. House Board from Musqueam (A50004), Gallery I.
3. House Post from Quamachan (Duncan) (A50005a), Gallery I.
4. House Post from Quamachan (Duncan) (A50005b), Gallery I.
5. House Post from Quamachan (Duncan) (A50005c), Gallery I.

Southern Kwagiutl

6. Human Figure from Alert Bay (A1800), Gallery 3.
7. House Post from Xumtaspi, Hope Island (A50007a), Gallery I.
8. House Post from Xumtaspi, Hope Island (A50007b), Gallery I.
9. House Post from Xumtaspi, Hope Island (A50007c), Gallery I.
10. House Posts and Beam from Xumtaspi, Hope Island (A50008 a,b,c), foot of Gallery I.
11. House Frame from Quattishe, Quatsino Sound (A50009 a,b,c,d,e,f), Gallery 2.
 Carved by Quatsino Hansen and George Nelson, ca. 1906;
 kneeling figures restored by Gerry Marks, 1976.

Figure 71. The deserted Southern Kwagiutl village of Xumtaspi on Hope Island in 1955. The three house posts on the left (catalogue nos. A50007 a,b,c) and the two house posts with a cross beam on the right (catalogue nos. A50008, a,b,c) are now in the Museum of Anthropology.

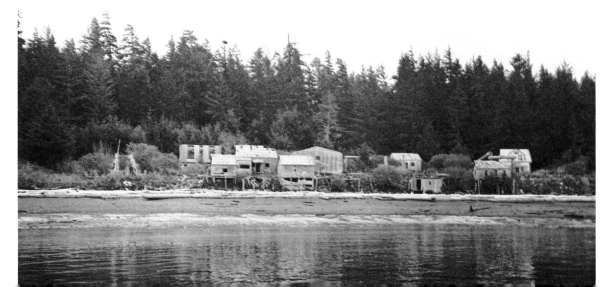

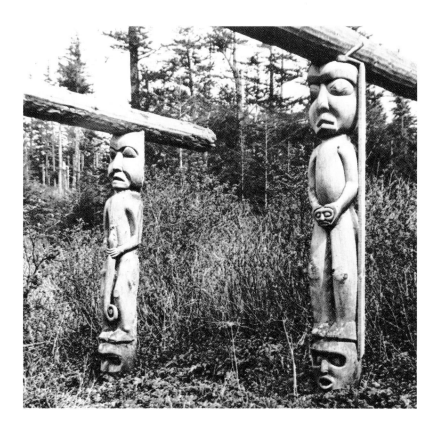

Figure 72. Hope Island house posts (catalogue nos. A50007b, right, and A50007a, left) in 1913.

Figure 73. Hope Island house posts (catalogue nos. A50007b, right, and A50007a, left) in 1955; note the amount of decay in 42 years.

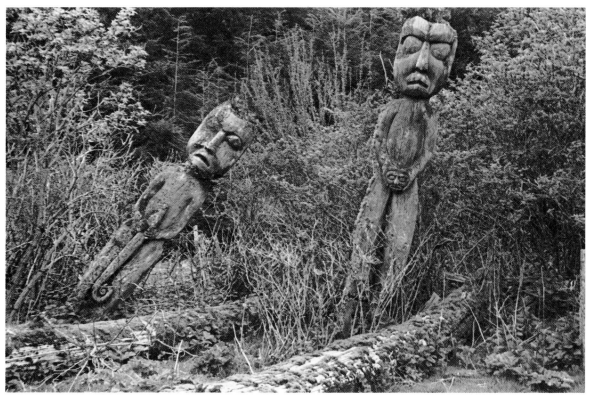

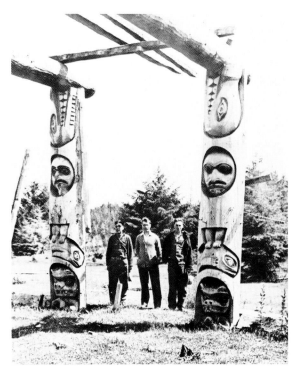

Figure 74. House post from Fort Rupert (catalogue no. A50027 right) before decay and salvage.

12.	House Post from Gwayasdums, Gilford Island (A50010a), Lobby.
13.	House Post from Gwayasdums, Gilford Island (A50010b), Lobby.
14.	House Post from Gwayasdums, Gilford Island (A50010c), Lobby.
15.	House Post from Gwayasdums, Gilford Island (A50010d), Lobby.
16.	House Post from Fort Rupert (A50027), Gallery I.
17.	House Post from Fort Rupert (A50036), Gallery 2.
18.	Memorial Pole from Alert Bay (A50037), Gallery 2.
	Carved by Mungo Martin of Fort Rupert in 1902 and restored by him in 1949.

Figure 75. Southern Kwagiutl memorial totem pole (catalogue no. A50038) from Fort Rupert after damage by fire and before restoration by Ellen Neel and Mungo Martin at the Museum of Anthropology (see also Figure 61).

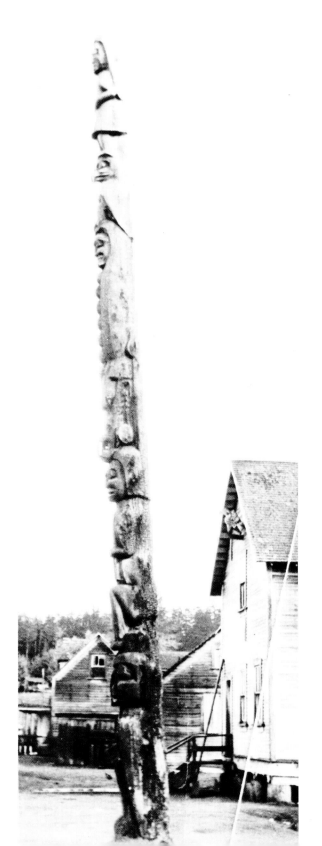

19. Memorial Pole from Fort Rupert (A50038), Gallery 2.
Carved by Charlie James of Alert Bay ca. 1900; later re-adzed and re-painted by Mungo Martin.

20. House Frontal Pole from Fort Rupert (A50041), Gallery 2.
Carved by George Hunt of Fort Rupert in 1914; restored by Ellen Neel, 1949, and Mungo Martin, 1951–52.

21. Human figure from Blunden Harbour (A50043), Gallery I.

Northern Kwagiutl

22. House Post from Kitamaat (A1778), Gallery 3.

23. House Post from Kitamaat (A1779), Gallery 2.

24. House Post from Kitamaat (A1789), Gallery 3.

25. House Post from Kitamaat (A1790), opposite the Research Collections.

26. House Frontal Pole from Rivers Inlet; re-erected in 1913 as a Memorial Pole (A50006), Gallery 2.

27. Model Totem Pole from Kitamaat (A6543), opposite Gallery 4.

Nishga (Tsimshian)

28. Base Section of Memorial Pole from Kwunwoq, later re-erected at Gitiks (A50020), Gallery 2.
Restored by Norman Tait of Kincolith and Conservators at the Vancouver Centennial Museum in 1976.

Gitksan (Tsimshian)

29. Memorial Pole from Kitwancool (A50019), Gallery 2.

Figure 76. Nishga memorial pole (catalogue no. A50020) from Kwunwoq after it was re-erected at Gitiks. The top section of the pole is in storage.

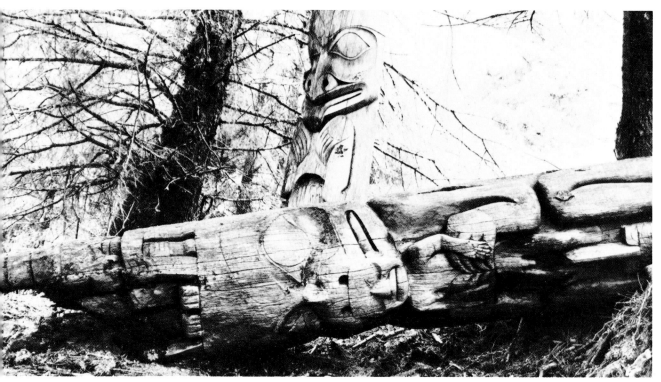

Haida

30. Sections of House Frontal Pole from Tanoo (A50000 a,b,c,d), Gallery 2.
31. House Frontal Pole from Skedans (A50001), Gallery 2.
32. Sections of House Frontal Pole from Skedans (A50002 a,c), Gallery 2.
33. Section of House Frontal Pole from Skedans (A50002b), Gallery I.
34. Base Section of Mortuary House Frontal Pole from Ninstints (A50012), Gallery I.
35. Base Section of House Frontal Pole from Ninstints (A50013), Gallery 2.
36. Sections of House Frontal Pole from Ninstints (A50014 a,b), Gallery 2.
37a. Section of House Frontal Pole from Ninstints (A50015b), opposite Gallery 5. (See also A50015a and A50018.)
37b. Section of House Frontal Pole from Ninstints (A50015a), Gallery 3. (See also A50015B and A50018.)
37c. Base Section of House Frontal Pole from Ninstints (A50018), Gallery 2. (See also A50015a and A50015b.)

Figure 77. Haida house front totem poles at Skedans (catalogue no. A50002a lying down in front; no. A50001 standing in back) before removal by salvage expedition in 1954.

(on facing page)

Figure 78. Haida totem poles at the deserted village of Ninstints in 1957. The tall pole at the centre right is now in the Museum of Anthropology (catalogue no. A50014 a,b).

Figure 79. Fallen Haida totem pole (catalogue nos. A50015 a,b and A50018) at the deserted village of Ninstints. This is the pole which inspired Bill Reid's copy (see Figure 58).

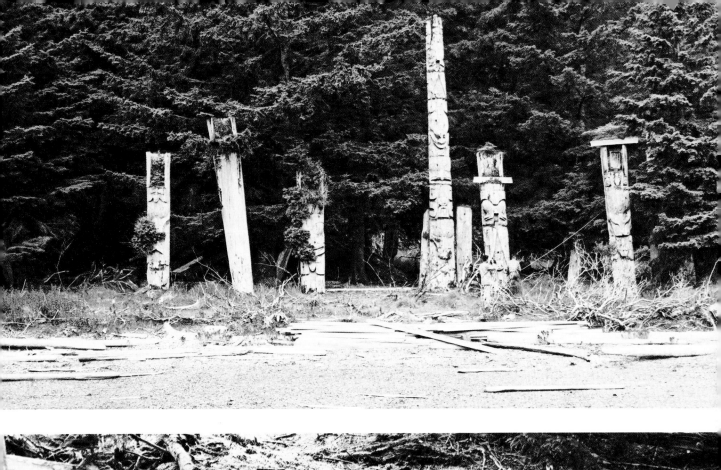
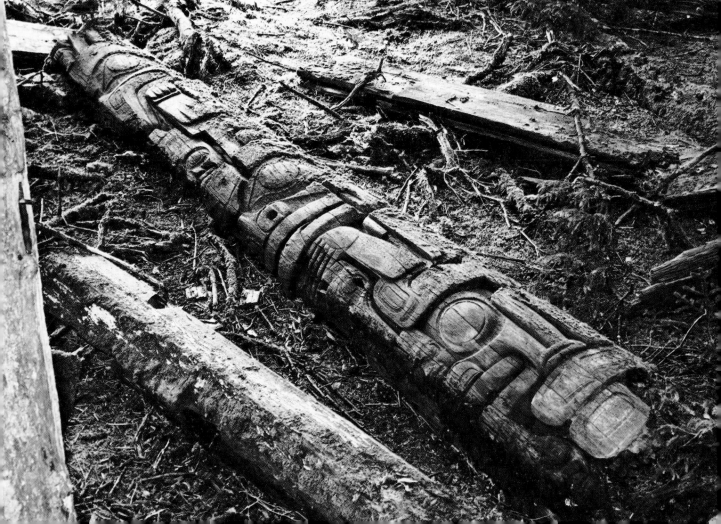

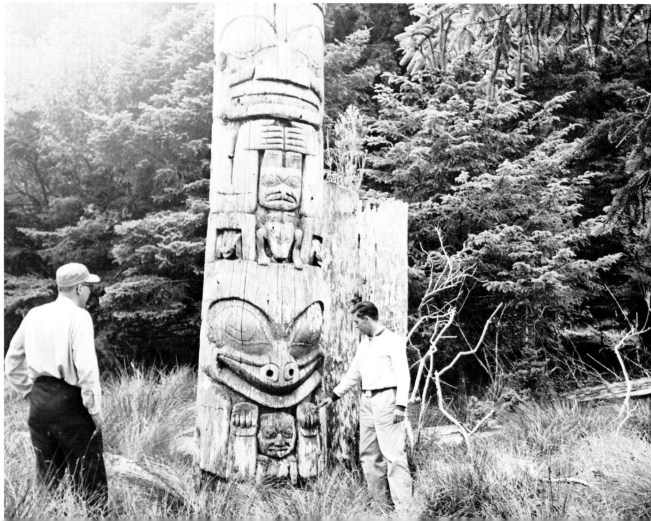

(on facing page)

Figure 80. Haida back-interior house post (catalogue no. A50016) at Ninstints in 1901.

Figure 81. Bill Reid (left) and Wilson Duff (right) examine the same pole 56 years later.

38. Back Interior House Post from Ninstints (A50016), Gallery I.
39. Base Section of Mortuary Pole from Ninstints (A50017), Gallery 2.
40. Model Totem Pole (A50024), Gallery 3.
41. Model Totem Pole (A6985), opposite Gallery 4.

Contemporary Poles Commissioned for The Museum of Anthropology

Southern Kwagiutl

42. Memorial Pole by Mungo Martin of Fort Rupert, 1951 (A50035), outside Gallery 2.
43. Memorial Pole by Mungo Martin, 1951 (A50040), outside Gallery 2.

Haida

44. Single Mortuary Pole by Bill Reid, of Skidegate descent, assisted by Douglas Cranmer, Nimpkish, of Alert Bay, 1960–61 (A50028), outside Gallery 2.
45. House Frontal Pole by Bill Reid, assisted by Douglas Cranmer, 1961–62 (A50030), outside Gallery 2.
46. Interior House Post by Bill Reid, assisted by Douglas Cranmer, 1959 (A50031), inside the Haida dwelling house.
47. Double Mortuary Pole by Bill Reid, assisted by Douglas Cranmer, 1960–61 (A50032), outside Gallery 2.
48. Mortuary House Frontal Pole by Bill Reid, assisted by Douglas Cranmer, 1959 (A50033), outside Gallery 2. This is a copy of a Ninstints pole (A50015 a,b, A50018) in Gallery 2, Gallery 3, and opposite Gallery 5.
49. Memorial Pole by Bill Reid, assisted by Douglas Cranmer, 1960–61 (A50034).

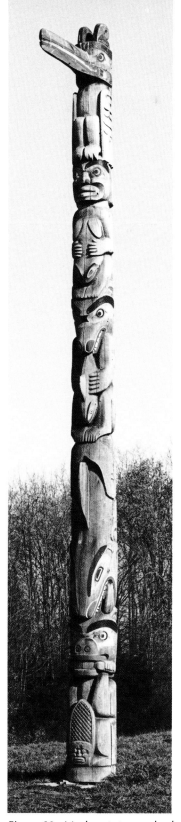
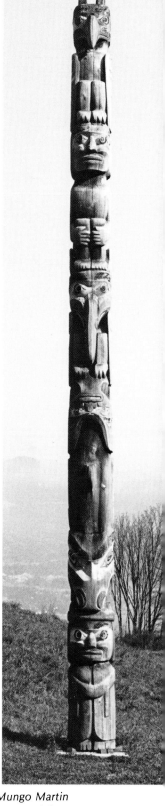

Figure 82. Modern totem poles by Mungo Martin (catalogue nos. A50035, right, and A50040, left) on the grounds of the Museum of Anthropology.

Nishga (Tsimshian)

50. House Post by Norman Tait of Kincolith, 1978 (Nb7.229), outside Lobby.

Gitksan (Tsimshian)

51. Totem Pole by the carvers of 'Ksan, 1980 (Nb7.244), outside Gallery 3.

Contemporary Sculptures Commissioned for The Museum of Anthropology

Haida

52. Bear by Bill Reid, 1963 (A50045), Gallery 2.
53. Wasgo (Sea Wolf) with Whales by Bill Reid, assisted by Douglas Cranmer, 1962. (A50029).
54. The Raven and the First Men by Bill Reid, assisted by George Norris and George Rammell and Gary Edenshaw, of Skidegate, and Jim Hart, of Massett, 1980.

Gitksan (Tsimshian)

55. Museum Doors by the carvers of 'Ksan, 1976.

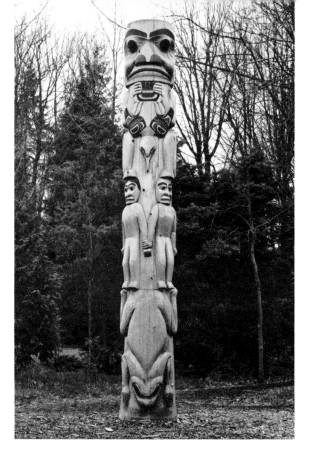

Figure 83. Modern Nishga house post by Norman Tait (catalogue no. Nb7.229).

Figure 84. Totem poles in museums acquire new uses for which their makers did not intend them, as objects once of local heritage are made available to all.

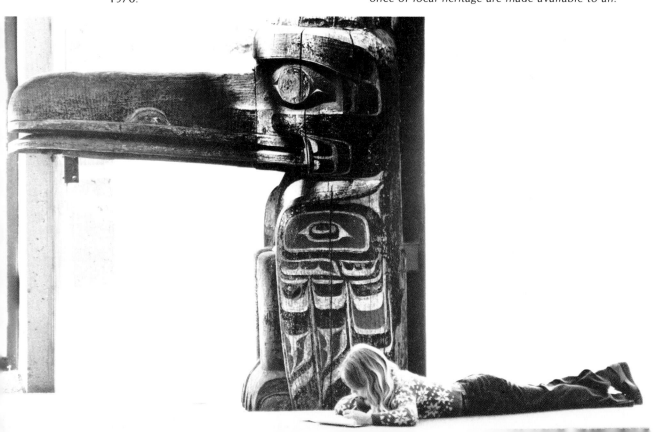

Suggested Reading

Barnett, Homer
 1938. "The Nature of the Potlatch", *American Anthropologist,* 40:349-358. A classic and enduring interpretation of the purposes of the potlatch.

Barbeau, Marius
 1929. *Totem Poles of the Gitksan, Upper Skeena River, British Columbia*. National Museum of Canada, Bulletin 61, Anthropological Series 12. Ottawa. Photographs and myths of the totem poles of the Gitksan, many of which are still standing in their original villages.
 1950. *Totem Poles*. 2 volumes. National Museum of Canada, Bulletin 119, Anthropological Series 30. Ottawa. The most comprehensive survey of the totem poles of the entire Northwest Coast; myths and illustrations.

Chapman, Anne
 1965. "Mâts Totémiques: Amérique du Nord, Côte-Nord-Ouest", *Catalogues du Musée de l'Homme, Série H, Amérique II*. An introduction to totem poles, based on those in the Musée de l'Homme, Paris.

Codere, Helen
 1950. *Fighting with Property*. Monographs of the American Ethnological Society, 28. New York. A review of the Kwagiutl potlatch, arguing that it was a ritual replacement for warfare.

Duff, Wilson
 1952. "Gitksan Totem-Poles, 1952", *Anthropology in British Columbia*, pp. 21–30. Victoria. A survey of those totem poles in Barbeau, 1929, which were still standing in 1952.
 1959. *Histories, Territories, and Laws of the Kitwancool*. Anthropology in British Columbia, Memoir 4. Victoria. Stories of several Gitksan totem poles, including A50019.
 1964. "Contributions of Marius Barbeau to West Coast Ethnology", *Anthropologica*, n.s., VI (1):63–96. Review of the arguments about the existence of totem poles at the time of European contact.
 1976. "Mute Relics of Haida Tribe's Ghost Villages", *Smithsonian*, 7(6):84–91. Abbreviated history of Ninstints.

Duff, Wilson, and Michael Kew
 1958. "Anthony Island, a Home of the Haida", *British Columbia Provincial Museum Annual Report for 1957*, pp. 37–64. Victoria. A history of the Haida village of Ninstints on Anthony Island and an account of the expedition which salvaged sections of 11 poles, including A50012, A50013, A50014, A50015, A50016, A50017.

Duff, Wilson, with Bill Holm and Bill Reid
 1967. *Arts of the Raven: Masterworks by the Northwest Coast Indians*. Vancouver: Vancouver Art Gallery. Holm's essay contains drawings and descriptions of the conventions by which the animal forms most common in the art may be recognized.

Garfield, Viola E., and Linn A. Forrest
 1961. *The Wolf and the Raven: Totem Poles of Southeastern Alaska*. Rev. ed. Seattle: University of Washington Press. Photographs and myths of Tlingit totem poles.

Goldman, Irving

 1975. *The Mouth of Heaven: An Introduction to Kwakiutl Religious Thought*. New York, Toronto: John Wiley & Sons. A modern interpretation of Kwagiutl religion and pot-latching.

Holm, Bill

 1965. *Northwest Coast Indian Art: An Analysis of Form*. Seattle: University of Washington Press. Exposition of the rules underlying Northwest Coast design, principally the two-dimensional style of northern groups. Introduces the formal vocabulary most often used in describing the elements of the art.

 1972. "Heraldic Carving Styles of the Northwest Coast". In Walker Art Centre, *American Indian Art: Form and Tradition*, pp. 77–83. New York: E.P. Dutton. The most precise description in print of Northwest Coast art styles, concentrating on facial renderings.

 1974. "The Art of Willie Seaweed: A Kwakiutl Master". In Miles Richardson, editor, *The Human Mirror: Material and Spatial Images of Man*, pp. 59–60. Baton Rouge: Louisiana State University Press. Detailed examination of the personal style of a master artist.

Keithahn, Edward

 1963. *Monuments in Cedar*. Seattle: Superior Publishing Co. Popular Introduction to totem poles; many illustrations.

Smyly, John, and Carolyn Smyly

 1973. *Those Born at Koona: The Story of Haida Totems*. Saanichton, B.C.: Hancock House. The totem poles of Skedans, including A50001 and A50002.

Photographic Credits